REFLECTING TRUTH

Japanese Photography in the Nineteenth Century

Edited by

Nicole Coolidge Rousmaniere
and
Mikiko Hirayama

SAINSBURY INSTITUTE
for the Study of Japanese Arts and Cultures

Hotei Publishing

Published by
Hotei Publishing
Royal Tropical Institute
Hotei Publishing
P.O. Box 95001
1090 HA Amsterdam
The Netherlands
www.hotei-publishing.com
www.kit.nl/publishers

ISBN 90-74822-76-2
NUR 654

Copyeditor
Linda Cook
Amsterdam, The Netherlands

Design
Peter Yeoh
London, United Kingdom

Production
Meester & de Jonge
Lochem, The Netherlands

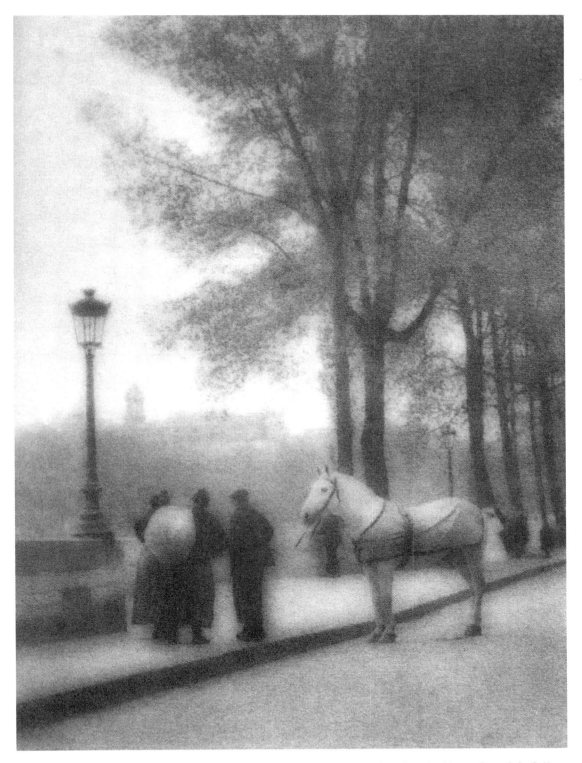

Frontispiece. Fukuhara Shinzō, *Horse Dealer*, 1913. From Ozawa Takeshi, ed., *Nihon shashin zenshū*, vol. 2: *Geijutsu shashin no keifu* (Tokyo, Shōgakukan, 1986), p. 34.

Contents

Introduction and Acknowledgements 8
Nicole Coolidge Rousmaniere
Mikiko Hirayama

Abstracts 12

Encounters with Foreign Photographers:
The Introduction and Spread of Photography in Kyūshū 18
Himeno Junichi

'I been to keep up my position':
Felice Beato in Japan, 1863–1877 30
Sebastian Dobson

Changing Views: The Early Topographical
Photographs of Stillfried & Company 40
Luke Gartlan

Packaged Tours: Photo Albums and Their Implications
for the Study of Early Japanese Photography 66
Allen Hockley

Portraying the War Dead: Photography
as a Medium for Memorial Portraiture 86
Kinoshita Naoyuki

'Elegance' and 'Discipline': The Significance of
Sino-Japanese Aesthetic Concepts in the Critical Terminology
of Japanese Photography, 1903–1923 100
Mikiko Hirayama

Contributors 109

Index 110

Introduction and Acknowledgements

The papers in this volume were originally presented at an international conference, 'Reflecting Truth: Japanese Photography in the Nineteenth Century', held on 2 November 2002 in Norwich, England. The conference, which was organised and sponsored by the Sainsbury Institute for the Study of Japanese Arts and Cultures, brought together specialists in the history of photography from Japan, Europe, Australia and the USA to share their ongoing research. The talks were well attended by the general public and specialists alike, with lively discussions following each of the panels.

The historic city of Norwich, where all of the conference events were hosted, is the home of the headquarters of the Sainsbury Institute for the Study of Japanese Arts and Cultures (SISJAC), which was founded in January 1999 through the generosity of Sir Robert and Lady Lisa Sainsbury. Envisioned as a Europe-based centre for advanced research in the arts, material culture and archaeology of the Japanese archipelago, the Sainsbury Institute was established in association with the University of East Anglia, Norwich, and the School of Oriental and African Studies (SOAS), University of London. The Institute's offices and newly established Lisa Sainsbury Library – located in the precincts of the beautifully preserved medieval Cathedral Close in Norwich – have facilities for visiting scholars and are regularly used for specialised lectures or colloquies related to Japanese art and cultural history. An important part of the Institute's academic mission is to help create research networks at an international level by supporting specialised projects and conferences such as the one represented here. The Institute also aims to disseminate the results of such projects through publication in various formats, in print and online.

The 'Reflecting Truth' conference clearly shows how scholarly investigation of Japanese photography in recent years has entered an important transitional stage – moving beyond a focus on introducing new discoveries and descriptions of collections to a more sophisticated investigation of photography in historical and cultural contexts. This research has been enabled in part by the greater accessibility of images through exhibitions, catalogues and scholarly publications, but also through remarkable advances in digital technology that have allowed scholars access online to previously inaccessible images. The collection of the Nagasaki University Library, which collaborated with the Sainsbury Institute on this project, has been a pioneer in digitization of early Japanese photographs. The position of photography itself within the canon of Japanese art is also undergoing reassessment. At one time marginalised as either a practical technique or amateur art form, photography has now earned full recognition as an area of scholarly inquiry inviting reflection on issues of visuality, technology, and national identity in Japanese art during its transition to modernity as well was in contemporary society.

Although speakers were given complete freedom to select their own topics, we were pleased to see how the papers dovetailed effectively to create a succinct but quite comprehensive overview of photography in Japan, from the initial experimental stages in the late 1840s, through the beginning of the modern period. To illustrate the papers, numerous examples of early photography are

reproduced here, many for the first time. Earlier versions of several of the essays were published soon after the conference in a special issue of *Koshashin Kenkyū* published by Nagasaki University, and we are grateful to the editors of that journal for allowing us to publish revised versions here.

The first essay included in this volume is by Himeno Junichi, Professor in the History of Economic Thought at Nagasaki University, who was instrumental in helping organise the original conference. Although Professor Himeno did not present a formal paper at the conference, he kindly responded to our request to submit an essay that reviews the early development of photography in Japan, especially as seen through interchanges between Japanese and foreign nationals. He notes that by 1846 a daguerreotype camera using silver-plate technology was already available in Deshima, the foreign trade outpost in the Bay of Nagasaki, but that it took several years before the camera technology was more fully understood by local Japanese photographers. Encounters between early Japanese pioneers of photography, including Furukawa Shumpei, Maeda Genzō and Ueno Hikoma, with the European photographers P. Rossier and Felice Beato spurred the advancement of the photographer's art in Japan.

The next essay by Sebastian Dobson, Honorary Librarian at the Japan Society in London and independent scholar, follows with a more focused study of the colourful figure of Felice Beato, who established a photographic studio in Yokohama in 1863. Until he sold his studio to Baron von Stillfried in 1877, Beato enjoyed a reputation as the premier photographer of Japan. We discover that the height of his activities coincides with one of the most tumultuous periods of change in modern Japanese history, and his surviving photographs capture the excitement and trepidation that accompanied the accelerated influx of Western technology into Japan. The entire genre of 'Yokohama *shashin*' (photographs), which dominated commercial photography in Japan for the remainder of the nineteenth century, owed much to Beato's efforts.

Luke Gartlan, who has just completed his doctoral thesis on at the University of Melbourne, continues the story of European photographers in Japan with a discussion of the career of Baron Raimund von Stillfried-Ratenicz (1839–1872), an Austrian aristocrat and former soldier-painter who is recognised as one of the influential figures in shaping foreign perceptions of Japan. Gartland proposes that his early photographs in many ways reflect the attitudes of the experiences and aesthetic sympathy of long-term foreign residents for their adopted country, rather than merely gratifying a tourist desire for a picturesque Far Eastern Arcadia. His essay reproduces several previously unpublished photographs from an album preserved in the Metropolitan Museum of Art, New York.

Moving from the age of the early pioneers of photography in Japan, Allen Hockley, Associate Professor of Asian Art History at Dartmouth College, focuses on photographic albums produced by commercial studios in the 1880s and 1890s. He charts their relationship between travellers' conceptions of Japan and the increased commodification of the photographer's art. Taking a consumer-centred approach to the study of early Japanese photography, he notes that commercial

photographers needed to be sensitive to the expectations of their primary clientele, the foreign tourist in Japan.

Shifting back and forth chronologically from images produced during the Sino-Japanese and Russo-Japanese wars to the recently founded Hiroshima National Peace Memorial Hall, Kinoshita Naoyuki of the University of Tokyo takes an innovative approach to explore the tradition of war portraiture in Japan. Professor Kinoshita notes that just as photography was becoming more widely available in the mid- to late-nineteenth century, a new category of death, the 'war dead', was being established. He also observes that at the same time the state began to exercise greater control of 'portraits of the war dead'. Although a great amount of time has passed since Japan's involvement in these international struggles, he demonstrates that the confrontation with memory of the 'war dead' is of great topicality for contemporary Japanese society and visual culture.

Mikiko Hirayama, Assistant Professor of Japanese Art History at the University of Cincinnati, Ohio, was based in London at the time of the conference as a Robert and Lisa Sainsbury Fellow at the Sainsbury Institute, and helped coordinate plans for the conference. Her paper concludes the volume with an essay that charts the transition from pioneering stages of photography in Japan into the modern era. She addresses the rise of what became known as Art Photography (*geijutsu shashin*) and the various tactics employed by photographers from the 1900s to the 1920s. At this juncture, amateur and professional photographers competed with each other over technical proficiency and artistic self-

awareness, while photography itself struggled to overcome the general perception of it being merely a practical skill, beneath other arts in traditional artistic hierarchies.

Finally, it should also be mentioned that two papers originally presented at the conference by Gotō Kazuo, an independent Tokyo-based researcher and former journalist with the *Asahi Shinbun*, and Richard Denyer of the Norwich School of Art and Design, are not included here, but are being revised by the respective authors for publication elsewhere.

Mr. Gotō presented his ongoing study of the career of William Gowland, an engineer who came to Japan in the 1880s to work in the mint at Osaka, but who was also an ardent amateur archaeologist and photographer. While living in Japan, Gowland undertook archaeological surveys of a number of ancient sites and built up an extensive collection of artefacts from the Jomon to early historical periods. This collection was purchased by A.W. Franks on behalf of The British Museum along with a remarkable collection of some 200 glass photographic plates of many of the archaeological sites he explored, which were only recently rediscovered in a storage area of The British Museum. Mr. Gotō has spent many years visiting many of the sites photographed by Gowland and has taken new photographs of them. His research has been recently published in a volume edited by Victor Harris and Mr Gotō entitled *William Gowland: The Father of Japanese Archaeology* (London: British Museum Press, 2003).

As the final speaker of the conference, Richard Denyer of the Norwich School of Art and Design, presented an engaging lecture from a broader international perspective

entitled 'A Strange and Unfamiliar Desire: A Personal Perspective on Early British Photographic Practice', which provided a Norfolk context for the development of photography in Britain. His talk helped spur further discussion of the interchange between Europe and Japan in the early stages of the development of photography.

The editors would also like to express their debt of gratitude to a number of individuals and organisations that guaranteed the success of both the original conference and this publication. We were particularly honoured that Professor Himeno could make the long journey from Nagasaki to Norwich to join in the conference and introduce the remarkable on-line database of nineteenth-century photographic images of Nagasaki. We would also like to acknowledge the enthusiastic support offered for this project from the start by Yasukouchi Yoshiki, Director of the Nagasaki University Library. Sebastian Dobson, in consultation with the Institute staff, helped steer the conference from the initial planning stages to the day itself. David and Paula Newman and Victor Harris lent encouragement and generous support at various stages. The Norwich School of Art and Design generously made available the Duke Street Lecture Theatre when we realised that the Institute's own facilities could not accommodate all those who wished to attend. Simon Kaner, Assistant Director of the Sainsbury Institute, worked with administrative staff, especially Hannah Brown and Hiromi Uchida to make sure that the logistics of conference went smoothly. For this volume, Hiromi Uchida also worked closely with the

authors in acquiring illustrations. Matthew Moran and Sarah Gordon assisted in the editing of the essays, with timely input from Cathy Potter and Julie Nelson Davis. Maki Kaneko kindly provided the translation of Professor Kinoshita's paper. Our designer Peter Yeoh worked with the editors to produce an attractive layout for the volume and patiently dealt with the revisions as they came in from authors and editors. Finally and most importantly we would like to extend our sincere thanks to the speakers themselves, many of whom travelled from abroad, for their engaging presentations and working with us in the production of this in-house publication of the Institute.

Nicole Coolidge Rousmaniere
Director
Sainsbury Institute for the Study of Japanese Arts and Cultures

Mikiko Hirayama
Assistant Professor
University of Cincinatti

Abstracts
Encounters with Foreign Photographers: The Introduction and Spread of Photography in Kyūshū

Himeno Junichi

The introduction and resultant dissemination of photography from Europe into Japan began from the southern island of Kyūshū. During the Edo period (1615–1868) Kyūshū's domainal clans obtained information regarding the outside world from Nagasaki, through the artificial island of Deshima where a small Dutch outpost was maintained, and it was originally from Deshima that photography was introduced to Japan. As literature on and foreign teachers of early photography were scarce in Japan, early photographic enthusiasts had to rely on encounters with foreign professional photographers to acquire photographic skills and knowledge. In this paper I review the development of early Japanese photography, especially as seen through interchanges between Japanese and foreign nationals.

It was around 1846 when the daguerreotype camera using silver plate technology was first brought to Japan. Ueno Shunnojō, a merchant and the father of Hikoma, who was to later become an accomplished photographer, obtained such an apparatus through Deshima and brought it to the Takeo clan. The clan returned it to the Dutch, however, because it did not understand how to use the camera. Subsequently, doctors residing in Deshima, such as Van den Broek and his successor Pompe and their Japanese

medical students attempted to take photographs with the aid of Dutch books and manuals. At the same time, the Satsuma and Fukuoka clans also tackled the process of photography. Each clan partially succeeded with silver plate technology by the latter half of the 1850s, which in turn could be said to be the dawn of photography in Japan.

The encounters between early Japanese pioneers of photography, such as Furukawa Shunpei, Maeda Genzō and Ueno Hikoma, with the French photographer P. Rossier brought about great developments in Japanese photography. Rossier came to Nagasaki as a correspondent of Negretti and Zambla, London and subsequently became the first photographer to sell landscape photographs of Japan in Europe.

Although Ueno Hikoma endeavoured to take photographs self-taught, his encounters with professional European photographers such as Rossier and Felice Beato greatly improved his skill. Uchida Kuichi, a student of Pompe, proved to be very successful as a photographer under the auspices of the medical doctor Matsumo Ryōjun, who practiced western medicine. Although Uchida Hikoma had only few apprentices by the time of his premature death (at age 32), he greatly contributed to the initial spread of photography in Japan.

'I been to keep up my position': Felice Beato in Japan, 1863–77

Sebastian Dobson

With his eccentrically phrased English, colourful Levantine background and flamboyant personality, the photographer Felice Beato (1834–c.1900) was one of Queen Victoria's more exotic subjects, and remains one of the most engaging figures in the history of photography.

When he established a photographic studio in the treaty port of Yokohama in 1863, Beato was at the height of his creativity. At this point he already had an impressive track record as a commercial photographer, having chronicled the Crimean War, the Indian Mutiny and the Second Opium War in China. Beato was therefore unique amongst his western contemporaries in Japan in his photographic experience. During the remainder of the 1860s, and well into the following decade, Beato enjoyed a reputation as the premier photographer of Japan, until he sold his studio to Baron von Stillfried in 1877.

Beato was born in Corfu in 1834 and his lifetime was characterised by drifting from place to place, his probable final resting place being in Burma. He made his home in Japan for over twenty years, the longest period of time he settled in any one country.

Beato's most active photographic period in Japan coincided with the tumultuous changes following the opening of the country to the outside world in the 1850s and the subsequent overthrow of the Shogunal government in 1867.

As outside the western imperial orbit and still largely inaccessible to foreigners, Japan demanded a new artistic approach from Beato, whose previous work was firmly rooted in recording the conflicts and triumphs of British military might. The result was an impressive portfolio of landscapes and portraits, artistic in execution and journalistic in intent, which revealed sensitivity to the Japanese landscape. Beato's lack of condescension towards Japan's inhabitants was unique in its time.

This paper seeks not only to examine the effect Japan had on Beato's work, but also to evaluate his place in the history of photography in Japan. The whole genre of 'Yokohama *shashin*', which dominated commercial photography in Japan for the remainder of the nineteenth century, owed much to Beato. In addition, recent research suggests that there was even some degree of interaction between Beato and pioneering Japanese photographers in Nagasaki and Yokohama.

Beato's work remains the first significant body of photographs taken by a western photographer living and working in Japan, and one with which both Japanese and westerners were familiar. The history of photography not only in Japan but also in its wider context is richer as a result of this important artistic encounter.

Changing Views: The Early Topographical Photographs of Stillfried & Company

Luke Gartlan

Baron Raimund von Stillfried-Ratenicz (1839–1911), an Austrian aristocrat and former soldier-painter, was one of the leading foreign photographers of nineteenth-century Japan. Throughout the 1870s, he managed a series of prominent studios in Yokohama, marketing his finely crafted albums to the thousands of foreign travellers en route around the world. In recent years, the rediscovery of several neglected collections, dating from the first years of his professional career (1871–1872) has drawn attention to his early concentration on outdoor excursion photography. Although better known for his studio-based, traditional genre subjects of Japanese society, Stillfried's reputation as a 'view' photographer deserves reassessment on the basis of these portfolios.

After outlining the general features of these portfolios, I will contend that the first works reflect the experiences and understandings of long-term foreign residents for their adopted country, rather than gratifying a tourist desire for a picturesque Far Eastern Arcadia. It is in this respect that an album preserved in the Metropolitan Museum of Art, New York occupies a pivotal position. This album was not only the principal document of Stillfried's early landscape work, but was also the former property of a long-term resident of Yokohama, the Reverend Samuel Robbins Brown, himself a pioneer amateur photographer in the port. I argue that for both producer and consumer, Stillfried's first portfolios operated within a distinctly residential discourse.

On returning from the Vienna World Exhibition in early 1874, Stillfried shifted his practice from the outdoors into the studio. His early works formed the core of his Japanese views for the remainder of the decade, but as the tourist market asserted its primacy, Stillfried altered and selected his negatives to reflect the changing demand toward more generic views of Japan. There were two major results of this practice. Firstly, by cropping the title from the original negative, Stillfried removed the initial residential context, making the print a more attractive memento for the globetrotter market. Secondly, the result of such alterations was to compromise the pictorial qualities of the original work. In considering the first portfolios, therefore, we can perhaps recognise Stillfried's professional development within the context of the treaty port Yokohama, and how the changing nature of the market affected his own practice.

Packaged Tours: Photo Albums and Their Implications for the Study of Early Japanese Photography

Allen Hockley

Any attempt to understand nineteenth-century Japanese photography must acknowledge that it was, for the most part, a commercial enterprise. Success in the business was dependant upon the photographer's sensitivity to the needs, desires and expectations of the primary market, that of foreign tourists. Accordingly, we must resist the tendency, so thoroughly conditioned in the practice of art history, to privilege the artists. Although the photographers produced the actual images, agency for the imagery ought to be posited with its consumers. In approaching the photographer, we may acknowledge a uniquely gifted eye or exceptional technique, but let us also recognise that genius may manifest itself in an entrepreneurial spirit, good business sense, or simply a knack for understanding what the market would support.

Souvenir photo albums afford several valuable insights into the commercial aspects of late-nineteenth-century photography in Japan. As the premier products offered by photography studios, they provide a unique perspective on the business practices the studios employed. In addition, each photo album possesses an underlying logic keyed to the preferences, passions, and predilections of the client who selected its images. Photo albums often mirror travellers' itineraries, functioning as visual records of what they saw and experienced. Albums compiled as gifts frequently present broader conceptualisations of Japan. Conversely, they can sometimes be more thematically specific. Albums are invariably gendered – often the interests and experiences of men and women who visited Japan dramatically diverged. Similarly, albums also indicate the class and occupation of their owners – the experiences and images a sailor or merchant sought and acquired were usually very different from those of a scholar or missionary.

Focusing on albums produced in the 1880s and '90s, when the trade in souvenir photo albums reached its peak, this article examines the relationship between travellers' conceptions of Japan and the business of promoting and selling photographs packaged in the album format. It probes the implications of a consumer-centered history of early Japanese photography and charts the direction such a history might take, noting both its advantages and limitations. By implication, it argues for a reconsideration of some of the paradigms currently informing the emerging study of early Japanese photography.

Portraying the War Dead: Photography as a Medium for Memorial Portaiture

Kinoshita Naoyuki

This paper discusses how the war dead were represented in portraiture and what role this played in late nineteenth-century Japan. Prior to the introduction of photography, painting and sculpture were the common media for memorial portraits. Photography became a new medium for this genre after the middle of the nineteenth century. At the same time, a new category of death – the 'war dead' – was established. Photography became popular in Japan during the 1860s to 1890s, just at the same time as conscription into the military was established. This signaled the beginning of state control of 'portraits of the war dead'. I examine in this paper the displays at the recently opened Hiroshima National Peace Memorial Hall for Victims of the Atomic Bomb, and in particular its portrait collection and display. By analysing this example, I aim to demonstrate that images of the war dead raise issues which are central to the understanding of contemporary Japan and its visual culture.

'Elegance' and 'Discipline': The Significance of Sino-Japanese Aesthetic Concepts in the Critical Terminology of Japanese Photography, 1903–1923

Mikiko Hirayama

The three decades encompassing the 1900s and 1920s were an important transitional period in the history of Japanese photography which marked the rise of Japanese pictorialism. This pictorialism became known in Japan as 'art photography' (*geijutsu shashin*). During this period, various photography periodicals occasionally featured articles that addressed the position of photography in contemporary Japanese society. One of the primary concerns expressed in these essays was how one could alter the prevalent view of photography as based on practical skill and thus lower in status than such fine arts as painting. Professional photographers often came under attack for lagging behind amateur photographers in terms of technical knowledge and self-awareness as artists.

This paper investigates the prevalent status of photography and its practitioners in early-twentieth-century Japan as evinced in contemporary essays. The two key words used repeatedly in this discourse were *shūyō* (discipline) and *shumi* (taste). These two concepts of discipline and taste were already in use within the intellectual and artistic milieu of early modern Japan. Indeed, early western-style painters and specialists of the Dutch studies (*rangakusha*) had already advocated the perspective of western empirical vision in both practical and artistic aspects. My paper analyses the continued prominence of these concepts of *shūyō* and *shumi* in modern Japanese visual culture and assesses how these concepts helped to define art photography, resulting in a new visuality essentially different from both western-style painting and other earlier types of documentary photography.

ENCOUNTERS WITH FOREIGN PHOTOGRAPHERS

The Introduction and Spread of Photography in Kyūshū

Himeno Junichi

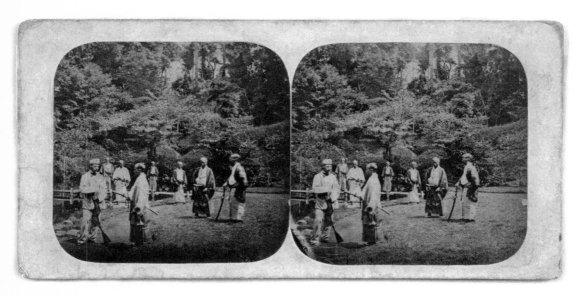

Fig. 1 Abel A.J. Gower and samurai in the garden of the British Legation, Tokyo. Nagasaki University Library.

The introduction and resultant dissemination of photography from Europe into Japan began from the southern island of Kyūshū. During the Edo period (1615–1868) Kyūshū's domainal clans obtained information regarding the outside world from Nagasaki, through the artificial island of Deshima where a small Dutch outpost was maintained, and it was originally from Deshima that photography was introduced in Japan.

The dawn of photography in Japan

The term 'camera obscura' (*donkuru cameru*), first appeared in Japan in the context of a Dutch/Japanese dictionary, the *Ransetsu Benwaku* (1788), edited by the *rangakusha* (Dutch scholar) Otsuki Gentaku. Gentaku translated it as *shashin-kyō*, literally 'photograph mirror'.[1] The technology whereby light passed through a pinhole into a dark box and was projected onto a glass screen to create a reversed image was transmitted from Europe in the eighteenth century, while the technique of fixing an image on metal, glass or paper was invented in Europe in the early nineteenth century.[2] Both the daguerreotype (*ginban-shashin*) and the photograph developed from a collodion wet-plate negative (*shippan-shashin*) were introduced to Japan through the Dutch factory at Deshima in Nagasaki Bay during the last decade of the Tokugawa Shogunate (1603–1867), when the policy of national isolation was reversed and selected ports were opened to foreign trade.

In the north-west of Kyūshū, the influential Saga clan played an important role in introducing the daguerreotype process to Japan. A major turning point in Dutch studies came in 1808 when the English warship *HMS Phaeton* entered Nagasaki Bay to attack Dutch ships at harbour. This was seen as a reason for the Saga clan to initiate the study of European armaments, as the Saga clan's ruling Nabeshima family had been in charge of guarding Nagasaki and failed to prevent the English incursion. The Saga clan received a heavy reprimand from the Tokugawa government as a result.

According to the *Nagasaki-kata hikae* (Nagasaki Diary) held in the Nabeshima archive in Takeo, a 'hoktmeter' that measured the density of both alcohol and liquid silver nitrate by specific gravity, indispensable for photography and glass production, was ordered from a Dutch merchant through the *Nagasaki kikiyaku* (The Nagasaki Listener) of the Saga clan in March 1838.[3] After the clan obtained it, they asked a Dutch merchant for instructions on its use in 1843. They succeeded in getting two more hydrometers in 1845 and another three in the following year from the merchant Ueno Shunnojō, the father of Ueno Hikoma. The specification was requested again in April of the same year. Furthermore it appears that the Saga clan succeeded in acquiring a daguerreotype camera, for a time at least, but then inexplicably returned it to Deshima with its original lens and attachments. If the Saga clan scholars had held onto this equipment and utilized it, they would have been able to claim the distinction of being the first to successfully practice photography in Japan.

According to another document, Ueno Shunnojō obtained a daguerreotype camera through Deshima in 1843, which is regarded as the first arrival of a camera in Japan. Although it appears that, after he made a sketch of it, he sent it back to the Dutch merchant, we can guess that it was probably the apparatus initially acquired by the Saga clan. Later, in 1848, Ueno Shunnojō acquired another complete set of daguerreotype equipment through the Dutch trading post. The correspondence between the Lord of the Satsuma domain, Shimazu Nariakira and Tokugawa Nariaki, Lord of the Mito domain and father of the future Shogun Yoshinobu, shows that Ueno Shunnojō sold the daguerreotype equipment to Shimazu, who at the time was enthusiastically conducting his own research into photography.

Dutch documents tell us that both the Nagasaki magistrate Takashima Sakuemon and the supervisor of the local office of the dōza (the Shogunal mint responsible for issuing copper coinage), Fukuda Naonoshin, ordered cameras from a merchant at Deshima in 1850 and again in 1852, and that, furthermore, by 1855 five cameras had reached Japan by this route. From the fact that Gallic acid was included in the list of imported chemicals and that the inscription 'physician's collodion' was penciled in the margin of a cargo list, the photo-historian Herman Moeshart of Leiden concluded that the wet-plate collodion process had already been introduced to Japan in 1855.[4] Jan Hendrik Donker Curtius, the last director of the Deshima factory, wrote in his diary on 13 July 1854 that photographs of some Japanese had been taken using a daguerreotype camera belonging to the American delegation.[5] Some five years later Julius L.C. Pompe van Meedervoort, a Dutch physician, wrote to Donker Curtius to tell him that he had succeeded in taking photographs in his chemical laboratory in Deshima, although with difficulty.[6] The mid to late 1850s therefore appear to have been the dawn of photography in Japan.

Achieving success in photography
In 1850, the Japanese fishing vessel *Eiriki-maru* was blown off course on a voyage from Harima, and its crew was later rescued by an American whaling ship in the Enshū Sea. These castaways were almost certainly the first Japanese ever to be photographed. An American daguerreotype artist Harvey R.

Marks took their portraits when they stayed in San Francisco in 1851.[7] The photographer Eliphalet Brown Junior, who accompanied Commodore Perry's fleet to Okinawa and Shimoda, took his first photographs of the scenery and customs of Japan with his daguerreotype apparatus in July 1853. A daguerreotype portrait of the Nagasaki-based interpreter Namura Gohachirō was taken in Yokohama and is now held at the Bishop Museum in Honolulu.[8]

Jan Karel van den Broek, a Dutch physician, was one of the first teachers of photography in Japan. He came to Deshima in 1853, as the successor to Dr. O.G.J. Mohnike and stayed for four years in Japan. His letters reveal that in 1856 he instructed some Japanese in the practice of photography. When Van den Broek asked Nagai Iwanojō, a Nagasaki magistrate, to procure silver for him, both Yoshio Keisai, a local physician, and Motoki Shōzō, a Nagasaki interpreter, replied that if he would teach them photography, the cost of the silver would be paid for by the Nagasaki Magistrate's office. Agreeing to this arrangement, Van den Broek asked a Deshima merchant to obtain a camera from the Dutch colony of Java. Van den Broek built a small dark room in the corridor connecting the pharmacy in his private house on Deshima. This was the first photographic laboratory established in Japan.

Furukawa Shumpei, a physician from Fukuoka, and Yoshio Keisai were the first students of Van den Broek. However Van den Broek complained after reading the user's manual which accompanied the camera that he would actually have to be an experienced photographer to give instruction in its use. Had he and his pupils been successful, it would have been the first occasion on which a photograph had been taken in Japan by Japanese. However the experiment seemed to end in failure; hope changed to disappointment with the accident suffered by the Dutch ship *Sara Yohanna*.[9]

In the middle of the 1850s, photographic research was underway in both Deshima and

Satsuma. The oldest surviving photograph taken by a Japanese photographer is a portrait of the Satsuma lord, Shimazu Nariakira. When he became the lord of the Satsuma clan in 1857, he ordered a Dutch merchant to purchase the apparatus and chemicals required for photography. He appointed both Kawamoto Kōmin and Matsuki Kōan (who later changed his name to Terashima Munenori) as translators of the Dutch books, and also Ushuku Hikoemon as a practitioner of photography.[10]

Nariakira was acquainted with Dutch books translated into Japanese. He knew Kawamoto of the Kuki clan as a physician. Kawamoto was employed as a subject of the Satsuma clan in 1857 after he had published a treatise in 1854 entitled *Ensei-kikijutsu* ('Concerning Strange Devices from the Distant West'), the first book in Japanese to describe the technique of photography. It seems that before his employment by the Satsuma clan, he already had some success in producing daguerreotypes in Edo.[11] Applying Kawamoto's knowledge and experience, both Ichiki Shirō and Ushuku succeeded in taking a photograph of Shimazu wearing *kamishimo*, or ceremonial dress, on 2 November 1857 (16 September Ansei 4 in the old lunar calendar). This photograph is now held at the Shōkō Museum in Kagoshima and represents the oldest daguerreotype taken in Japan by a Japanese.[12]

There is also a record of Matsuki's interview with a Dutch officer at Kagoshima in an entry dated May 1857 in the diary of Willem Johan Cornelis van Kattendijk, in which it is mentioned that 'Matsuki Kōan learned photography from Van den Broek, and he seems happy to take photographs of the scenery and so on'.[13] If this were true, Matsuki would have already succeeded in taking photographs at Kagoshima before the portrait of Lord Shimazu was taken.

Kuroda Nagahiro, lord of the Fukuoka domain and grand-uncle of Shimazu Nariakira, was presented with a daguerreotype with which he amused his daughters. Through the

efforts of Furukawa Shumpei, a subject of the Fukuoka clan and one of Van den Broek's students, one experiment in 1857 succeeded in fixing an image of 'two half-length statues' on a plate. However, this does not necessarily mean that a satisfactory picture was obtained. Kuroda mentioned in a letter to Date Muneshiro, lord of the Uwajima domain, that photography was too difficult even for Pompe van Meerdervoort to do by himself.[14]

Julius L.C. Pompe van Meerdervoort came to Nagasaki in September 1857 to succeed Van den Broek as physician at Deshima, and he stayed in Japan for five years. He soon opened a chemical laboratory at ōmura-machi in Nagasaki, where Matsumoto Ryōjun was employed as a supervisor. He taught photography to Maeda Genzō and his fellow Fukuoka clansmen, Furukawa Shumpei and Kawano Teizō, who had also studied previously under Van den Broek. Pompe later wrote:

'After I taught Maeda photography, he was promoted to the post of official photographic artist to the lord of Fukuoka. His lord gave him a large salary and took him everywhere with him whenever he made a journey'.[15]

Matsumoto also refers to Maeda's apprenticeship in his autobiography *Ranchū Jiden*. In 1859, the Fukuoka clan established a chemical laboratory with an attached darkroom for photographic use in Fukuoka Castle. A research institute for the study of photography which was sponsored by Furukawa Shumpei was located near the Naka River in Fukuoka.[16]

Both Ueno Hikoma, who took over his family business as a manufacturer of potassium nitrate, and Horie Kuwajirō, who came to the *Kaigun Denshūsho* (the Shogunal Naval College) from the Tsu clan, learned Dutch chemistry at the chemical laboratory where Pompe was asked to teach. According to a letter Pompe later wrote, he finally succeeded in creating a photographic image using the wet-plate collodion process in December 1859.[17] Matsumoto, who witnessed the experiment testified: 'it finally came out as a meagre black shadow... it was completely unclear to me, however, what the subject was.'...'Let's ask Pompe.'[18] Furthermore, the Dutch merchant Albert Johannes Bauduin wrote in a letter to his sister: 'since Pompe is engrossed in taking photographs, perhaps I should ask him to take one of me. Please don't expect too much, however. There is a serious risk that I will be photographed as an ugly man.'[19]

There are many records of early photographers across Japan who went to Nagasaki to study Dutch knowledge and technology, such as Kitamura Tōkoku of Edo, Nakajima Yahei, Ono Tamehachi and Yamamoto Denbei of the Hagi clan at Chōshū, Kikuchi Tomitaro and Shunzō Yanagawa of the Mito domain, and Kawasaki Domin and Kikizu Mataroku of Saga. The names of Sakuma Zōzan, Iinuma Yokusai, Ōtori Keisuke and Ōno Benkichi are also known as independent pioneers of photographic research at this time.

The role of the French photographer P. Rossier[20]

Matsumoto Ryōjun wrote in his diary that he ordered Maeda Genzō to assist Rossier, who was described at the time as an 'English' photographer. When Maeda came to Nagasaki with a set of daguerreotype apparatus (presented by Shimazu Nariakira to Kuroda Nagahiro), he accompanied Rossier for 30 days to learn photography. It provided a good opportunity for his tentative success in the medium. Rossier ascribed Pompe's failure to the fact that he lacked the necessary chemicals. As Rossier felt a debt of gratitude to Maeda, he gave him a letter of recommendation for acquiring photographic apparatus and chemicals in Shanghai.[21] Other students of Rossier included Furukawa Shumpei and Kawano Teizō.

According to the text of an interview with Furukawa by his son-in-law Shinjirō, the early

history of photography in Fukuoka owes much to the fact that Maeda and his fellow students were able to learn the practical application of photography while escorting Rossier through Nagasaki, especially when he was taking pictures of priests, beggars and a crowd of townspeople watching sumo wrestlers.[22] Though Kawano wrote the textbook *Shamitsu binran* (A Handbook of Chemistry) based on a translation from Dutch, he was unable to take photographs successfully. It was only Maeda who achieved any success through the aid of the so-called 'Englishman', Rossier. This misunderstanding about Rossier's nationality – he was most likely French – probably resulted from the way in which he introduced himself, since we can speculate that he would have described himself as a special artist dispatched to Japan by the firm of Negretti and Zambra in London. Both Maeda and Furukawa were delighted to be able to buy lenses, chemicals and albumen paper from Rossier. They then had the opportunity to show their purchases to the lord of Fukuoka and attempt to take pictures. This story tells us the importance of a pioneer in practice. The day in 1860 on which they succeeded in taking a photograph – 28 October (15 September according to the old lunar calendar) – is still a memorial day in Fukuoka.

Some of the photographs taken by Rossier in Japan can still be seen.[23] One of these, which is stored in the Public Record Office in London, accompanied a report sent to the British Minister in Japan, Rutherford Alcock, by Morrison, the Consul in Nagasaki, on 13 October 1860, and consists of a panoramic view of the foreign settlement at Ōura in Nagasaki, which was still in the course of construction. The Siebold Memorial Museum in Nagasaki owns another important image by Rossier which shows Philip Franz von Siebold, his son Alexander and a group of samurai of the Saga clan at the temporary residence of the British Consul in Nagasaki in the summer of 1859.

According to an interview given by Ueno Hikoma in 1902 both Ueno and Horie Kuwajirō were also among those who received instruction in photography from Rossier.[24] Apparently, when faced with what Rossier had to show him, Ueno was so overwhelmed by the gap in refinement and technology that he completely gave up any idea of making a camera by himself. Acknowledging the superiority of French-made apparatus, they submitted a plan to purchase a camera and chemicals from France using funds provided by Tōdō Takayuki, lord of the Tsu clan. They succeeded in obtaining both for 150 ryō half a year later through a Dutch merchant. Ueno was so satisfied with the new equipment that he agreed to become a subject of the Tsu clan in order to accompany it to Edo. The encounter between Ueno and Horie was a major step in the progress of Japanese photography in Edo. Rutherford Alcock described how a member of his staff, Abel A.J. Gower, set about taking photographs during a journey to Edo in 1860.[25]

Nagasaki University Library houses a few stereoscopic photographs taken by Rossier, one of which shows a westerner (possibly Gower) holding a gun together with *yakunin*, or Shogunal officials, in the garden of Tōzenji temple (fig. 1), which temporarily housed the British Legation in Edo. There is also another group of six photographs which are known to have been taken by Rossier.[26] We also know of one photograph in Nagasaki University Library inscribed on the reverse 'Nangsaki Bay, June 1859 by Abel A. Gower', which shows Myōgyōji temple, the site of the first British Consulate in Nagasaki.

On 3 October 1860, *The Times* (of London) published an article entitled 'Photographs from Japan' which reported the imminent arrival of 'a case of rare and curious photographs of the scenery of this interesting country, and illustrative of the manners and customs of the Japanese tribes' taken by a special artist commissioned by Negretti and Zambra of London, which was expected on the Peninsular and Oriental Steamship Company's steamship *Ceylon*. These photographs were

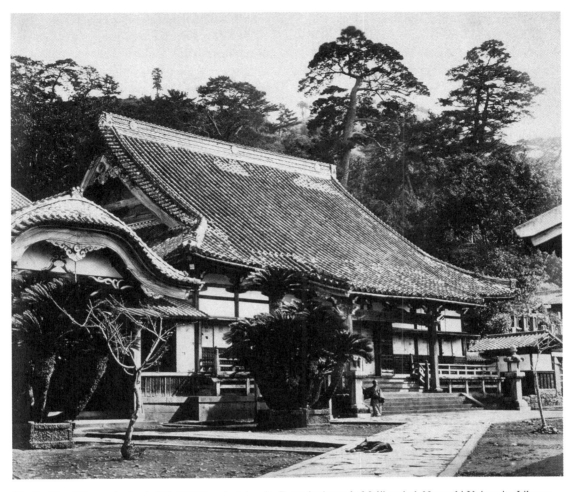

Fig. 2 Ueno Hikoma in front of Daikōji Temple, taken by Beato in the early Meiji period, Nagasaki University Library.

most likely taken by Rossier, an employee of the company who had already been active on its behalf in China. A set of 100 stereographs entitled 'Views in Japan' is known to have been on sale in London around this time. These photographs appear to be the first topographic and photographic images of Japan commercially available in Europe.[27]

Ueno Hikoma and western photographers

Ueno Hikoma was born in Ginya-machi in Nagasaki the second son of Ueno Shunnojō in 1838.[28] When his father died, he aspired to learn chemistry in order to continue the family business, which involved nitre powder production and chintz dyeing. Three members of the Tsu clan, Horie Kuwajirō, who was learning military science at that time, Mizuno Hokae and Nagai Gennai, together with Nakamura Kasuke from the Saga clan succeeded in persuading their feudal lords to assist in the establishment of a chemistry laboratory at Ōmura-machi in Nagasaki. Pompe van Meerdervoort concurrently held two teaching positions in medicine and chemistry. Hikoma had developed an interest in photography during his studies in Dutch chemistry as a student. Hikoma's success story in photography at this time was described in a newspaper article entitled *Nihon shashin no*

23

kigen (The Origin of Photography in Japan) published in the Tōyō Hinode Shinbun in 1902. Employed by Lord Tōdō of the Tsu domain, Hikoma stayed at the clan residence in Edo at Kanda in 1860. An early glass-plate portrait of the 23-year-old Hikoma taken by Horie in their Edo laboratory in 1861 is now stored in the Nagami Tokutarō Archive at the Faculty of Art, Nihon University.[29]

After Hikoma moved to Tsu he co-authored a treatise on chemistry, *Shamitsu kyoku hikkei*, with Horie, which served as a textbook at the clan school. It was written using several translations extracted from ten Dutch manuals. An appendix to the book entitled *Satsueijutsu*, or 'The Technique of Photography', described not only the collodion wet-plate photographic process but also the method of asphalt printing invented by Niepce, and was the first description of lithography printing published in Japan.

When Hikoma returned to Nagasaki, he found out that his teacher, Pompe, had left Japan to return to his home country. He duly abandoned his pursuit of *rangaku* and in the autumn of 1862 opened a photographic studio in Nagasaki beside Nakashima River with a signboard advertising himself as a 'first class photographer'. For a while it seemed that photographers encountered considerable trouble in persuading people to have their photographs taken: this was the result of a popular superstition which regarded the camera as a device of 'Christian sorcery'. However the number of customers at the studio gradually increased, and included foreigners, feudal lords and their clansmen, and the townspeople of Nagasaki.

Several famous patriots who rebelled against the Bakufu, or Shogunal government, such as Takasugi Shinsaku, Itō Shunsuke, and Sakamoto Ryōma, all had their portraits taken at Ueno's studio during the Keiō era (1865–67). Although Hikoma did not specifically retail albums as souvenirs, he does seem to have made some albums at the special request of his foreign customers. Through selling expensive photographs, Ueno was able to accumulate enough wealth to obtain more expensive materials for the practice of photography, and to expand his studios. Though Ueno's technique had improved through his acquaintance with both Pompe and Rossier, it was his encounter with Felice Beato, the Yokohama-based photographer who frequently visited Nagasaki, that seemed to contribute much to his development as a photographer. While in Nagasaki, Beato borrowed Ueno's photography studio and took portraits of Ueno's younger sister, his acquaintances and merchants in the town. Beato also took a view of Daikōji temple in which Ueno himself appears (fig. 2).[30]

A photograph of Deshima taken by Beato is contained in an album produced by the Ueno studio stored in the collection of Ishiguro Keishō.[31] The two photographers seem to have exchanged their photographs. Recently, I found a picture taken by Beato outside Zōjōji temple in Shiba, which shows a group headed by Hikoma sent to take photographs in Edo.[32] This illustrates the close relationship which existed between the two photographers. I intend to examine this subject in more detail in a separate paper. Koenrad Walter Gratama, who came to Nagasaki as a teacher at the *Bunseki kyūrisho* (Chemical Analysis Laboratory) attached to the medical school at the Seitokukan (the old Yōjōsho), instructed Hikoma in chemistry in 1866. The Austrian Wilhelm Burger was another foreign photographer who seems to have taught Hikoma.[33] From a series of stereographs of Japanese subjects, which Burger published in his native Austria, we can see that some of them were taken in the Ueno studio (fig. 3), which would indicate that when he came to Nagasaki, he borrowed the stereographs from Ueno. This encounter must have provided another good opportunity for Hikoma to improve his photographic skills.

Uchida Kuichi

Uchida Kuichi was born in 1846 and received an education over several years from his uncle, Yoshio Keisai. Since Yoshio himself learned

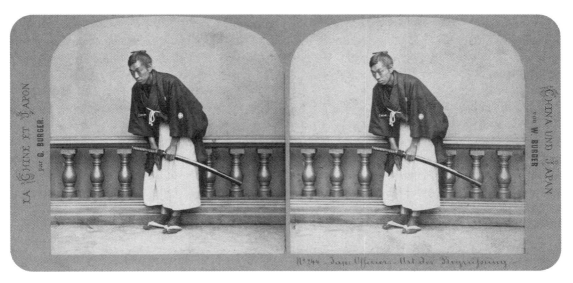

Fig. 3 Officer's greeting, taken at Ueno's Studio by Wilhelm Burger in the early Meiji period. Nagasaki University Library.

photography from Van den Broek, we can infer that Uchida also acquired knowledge of photography at this time. While operating a pharmacy, which brought him into contact with Dutch merchants at Deshima and the nearby Foreign Settlement at Oura, Uchida became acquainted with Pompe. He was permitted to learn photography after applying to the Nagasaki magistrate. He also studied pharmacy under Horie Kuwajirō. The relationship between Uchida Kuichi and Ueno Hikoma was a complicated and delicate one, since it was a mixture of apprenticeship, friendship and rivalry. According to a short biography of Uchida written by his student Iioka Sennosuke, he always denied that their relationship was simply that of master and apprentice: 'we were in friendly rivalry'.[34]

Uchida further pointed out that, unlike Ueno who was prevented from concentrating exclusively on photography because of the demands of his watchmaking business, he was able to devote his best efforts to the practice of photography. As a merchant, Uchida could earn a large amount of money through the import of cameras, chemicals, lenses, and so on after 1863.

Possibly in order to avoid confusion

between himself and Ueno, Uchida moved from Nagasaki to Kobe where in 1865 he opened a studio in partnership with Ueno Sachima, a younger brother of Hikoma. Soon afterwards, he moved again to Semba in Osaka, where he took portraits of samurai from various clans who were serving as part of a shogunal military expedition against the Chōshū domain and were undergoing training in Osaka Castle. After working for an Osaka magistrate called Ōkubo, Uchida attained samurai status and moved to Edo in 1866 on the shogun's warship *Kaiten-maru*. Uchida stored his photographic equipment safely in a warehouse at Teppōzu, meaning that it was kept safe and he later used it to take photographs of many samurai during his stay at the mansion of Matsumoto Ryōjun.[35] When Matsumoto fled to the north-east of Honshū following the overthrow of the shogun, Uchida took refuge in Yokohama, where, supported by an investment from Ishikawa Shinsuke, he opened his studio on Bashamichi in January 1868. There he was able to take many photographs of soldiers serving in the Imperial army during the latter part of the Boshin War. Moreover, he received a commission from the office of the governor of Kanagawa Prefecture to take photographs,

25

which were then used as an anti-forgery measure for the locally-issued paper currency. When he established a branch studio at Kawaramachi Asakusa in the new capital of Tokyo in 1869, Uchida was known as a seller of photographic portraits of Kabuki actors.

He was also commissioned by the Imperial Household Agency to take photographs of Edo castle, the official portraits of the Emperor and Empress Meiji and the Empress Dowager and to record the itineraries of the Imperial Visits to Kansai and Tōhoku. When Uchida accompanied the Emperor to Kyūshū in 1872 as an officially accredited photographer, he took many photographs of the places visited by the Imperial party.[36] We assume from the appearance of identical photographs in albums issued around this time by the studios of Uchida and Ueno that, when Uchida visited Nagasaki, his old friendship with Ueno had completely recovered. Uchida died suddenly on 17 February 1875, aged only 32, after catching pneumonia. According to Iioka, the eldest daughter of Uchida's relative, Umata Yoshiko, inherited his property. Uchida Kuichi was buried in Kajiwaragō Ōjimura Kitatoyoshimagun in Tokyo. The names of Uchida Seisuke, Arai Hachirō, Iioka Sennosuke, Hasegawa Kichijirō and Koga Kingo are recorded as his pupils.

Pupils of Ueno Hikoma
Uchida regarded Ueno as a fellow former pupil of Pompe van Meerdervoort, and, for this reason, Uchida cannot be described as one of Ueno's pupils in the strict sense of the word. Ueno Hikoma had many students, such as Kameya Tokujirō (from Chōshū), Tomishige Rihei (Yanagawa), Nakajima Shinzō (Kumamoto), Nagai Nagayoshi (Awa), Noguchi Jōichi (Kurume), Nakajima Seimin (Kurume), Tanaka (Tosa) and Morita Raizō (Osaka). Nagai, who is regarded as the pioneer of the study of chemistry in Japan, had first arrived in Nagasaki intending to study under the Dutch teacher Gratama, but, finding that

Gratama had just left Japan, he became a pupil of Ueno's instead. In 1871, he went abroad to study at Berlin University, where he stayed for 14 years. After he returned to Japan in 1884 Nagai was employed as a Professor at Tokyo University, and he went on to establish the Department of Pharmacy and Chemistry at Tokyo University in 1893. Kameya Tokujirō first learned photography from a Dutchman at Deshima. After studying with Ueno Hikoma, Kameya is believed to have been the founder of a studio at the Chion'in in Edo in 1862.

After learning from Kameya, Tomishige Rihei met Ueno in 1864. When he returned to Yanagawa, he immediately opened a photo studio. However, he soon returned to Nagasaki, to ask Kameya to resume teaching him photography, and from 1868 to 1869 Tomishige was his student again. Though Kameya passed away in Vladivostok in 1884[37] his daughter Toyo succeeded him, and is still well-known today as the first woman photographer in Japan. Tomishige opened his studio at Setaka in Kumamoto in 1870. He photographed various locations in the town, including the headquarters of the Sixth Army Division (the old castle flower garden) in 1870, Kumamoto castle, the Yamazaki parade ground and the Suizenji Garden in 1872. He left many photographs of Kumamoto castle taken just before it was burned down during the Satsuma Rebellion in 1877, and several views of the battlefields.

The intimate relationship between Ueno and Tomishige seems to have continued until Ueno died in 1904.[38] Photographers such as Iwashita Yaichirō (Pyongyang, Korea), Matsumoto Sada, Uozumi Shigeru (Hitoyoshi), Shioyama Kōzō (Shimabara) and Sodesaki Jiichi (Yanagawa) are recorded as disciples of Tomishige. They could be described as the second generation of Ueno's disciples.[39]

Kikizu Mataroku and Egoshi Einojō from the Saga clan trained themselves under the auspices of Ueno Hikoma. According to the archives of the ruling Nabeshima family, they

26

first purchased a camera for 250 *ryō* from a Nagasaki merchant called Takebayashi Yūsaku. Their lord then ordered both of them in 1868 to go to Nagasaki to learn photography from Ueno. At first, Ueno refused to teach Kikizu. However, Kikizu was finally permitted to practice photography in late April of that year. As Kikuzu had previously heard that a hydrometer was necessary for photography and that one had been sold to the Saga domain, he asked Takebayashi to send it to Nagasaki. It is probable that his initial trouble with Ueno was related to money. In fact, according to Kikuzu, when Ueno talked about the superiority of American and French photographic techniques and in particular components, such as paper and lenses, compared to what British manufacturers could offer, he also complained about the high prices they commanded, especially albumen paper, which was being sold at that time for 100 *ryō* per box. However this story may have been told in order to excuse Kikuzu for the poor quality of the photographs which he sent back to Takeo as a sample, and he entreated the Saga clan to provide Ueno with the necessary funds to help him purchase these expensive photographic materials.[40]

At this point, we should also mention that Setsu Shinichi opened a photographic studio at Shin-machi, Nagasaki in 1869. He frequently went to the studio of Shimizu Tōkoku at Asahi-machi in Yokohama over a six-month period to learn photography. He returned to Nagasaki in 1869, where he opened his studio.[41] When, in 1877, Ueno Hikoma was employed by the governor of Nagasaki prefecture, Kitajima Hidetomo, to take photographs of the battlefields of the Satsuma Rebellion for a fee of 330 yen for 420 prints, both Setsu and Noguchi Jōichi accompanied him.

Ueno also merits particular consideration after he co-operated with the official United States astronomical expedition to Nagasaki in 1874 to photograph the transit of Venus. These photographs are now held by the Department of Arts at Nihon University.

When in 1899 Ueno Hikoma hosted a convention of photographers in the vicinity of Kyushu, he composed a list of active photographers in the area. In the Nagasaki area, Ueno names the following: Tamura Tokisaburō opened his studio at Shinchi-dōri Nishihamano-machi in 1878. At the same time, Kiyokawa Isosaburo, who was an apprentice of Ueno, established his studio. Tamemasa Torazō, who had no relation with Ueno and had trained himself in Tokyo, also opened a studio at Nagasaki in the 1890s. Rikitake Masao opened his studio at Hirado early in the same decade. The studio of Matsuo Kenji was opened in Motoshikkui-machi in Nagasaki in 1893. Hoshiyama Kichitarō opened a studio at Funadaiku in Nagasaki in 1894 before moving to Manchuria in 1900.

Also on this list we can find Kiyokawa Takeyasu (Motofurukawa-machi), Takeshita Keiji (Motoshikkui-machi), Watase Sadanojō (Ginya-machi), Kumashirō Nobuhiro and Urata Tasaburō (Funadaiku-machi), Tamemasa Torazō (Moto-kago-machi), Koga Saroku (Funadaiku-machi), Isoda Teiichi (Motokago-machi), Matsuo Kenji (Motoshikkui-machi), Tsuruta Umetarō (Motokago-machi), Kawai Tōroku (Motoshikkui-machi), Shimizu Kyutarō (Oide-machi), Urata Moichi (Uchinai-machi), Morōka Shirō (Ōura) and Kodate Onojirō (Nishiyama). The book *Kyūshū shadanno kaiko* (Recollection of the Association for Photographers in Kyūshū) published in 1960 supplements this list with the names of another seven photographers active around 1900.

Until the 1920s, the total number of commercial photographers active in Kyūshū stood between 70 and 80, and of these, a significant percentage were former disciples of Ueno Hikoma. The need for a regional photographic association was keenly felt. However, when a preparation meeting was initiated in 1897, it was Furukawa (also known as Watanabe) Shinjiro of Fukuoka who took the lead and not Ueno. Indeed the *Kyūshū Chiku Shashin Dōgyō Dai-konshinkai*

(Convention of Photographers in the Kyūshū Area), held at Kurume in the following year, was conducted without Ueno even being present. The convention did, however, nominate Mitoma from Fukuoka and Tomoshige from Kumamoto to negotiate with Ueno concerning the organisation of photographers in Kyūshū area. Ueno drafted a plan of the rules for the *Kyūshū Shashinshi Shinboku-kai* (Friendly Association of Photographers in Kyūshū). Although Ueno summoned another Friendly Convention in November of same year in 1897 the number of participants was limited.[42]

The location of the Friendly Association of Photographers in Kyūshū was of some dispute during the 1900s.

Notes

1 Dai-ichi Art Centre, ed., *Nihon shashin zenshū* (Tokyo: Shōgakukan, 1988), pp. 186–7; Himeno Junichi, 'Nihon no kindai-ka to koshashin no kokusai jōhō-sei', *Koshashin kenkyū*, no. 1 (Nagasaki: Nagasaki University Library, 1995), pp. 22–45.

2 Ozawa Takeshi, *Bakumatsu shashin no jidai* (Tokyo: Chikuma Shoten, 1994); Nihon Shashinka Kyōkai, ed., *Nihon shashinshi nenpyō 1840–1945* (Tokyo: Heibonsha, 1971); Ishiguro Keishō, *Utsusareta bakumatsu* (Tokyo: Akashi Shoten, 1990).

3 Himeno Junichi, 'Kaigai jōhō to Kyūshū: Deshima to Kyūshū shohan no jōhō network', in Himeno Junichi, ed., *Kaigai jōhō to Kyūshū: Deshima, Seinan yūhan* (Fukuoka: Kyūshū Daigaku Shuppan Kyōkai, 1996), pp. 7–8.

4 Herman Moeshart, 'Nihon shashinshi ni okeru gaikokujin no yakuwari', in Gotō Kazuo and Matsumoto Itsuya, eds., *Yomigaeru bakumatsu: Raiden Daigaku shashin korekushon yori* (Tokyo: Asahi Shimbunsha, 1986), p. 222. Moeshart's research drew extensively on the records of the Deshima Factory held at the Dutch National Archives in The Hague.

5 Mineko Vos, *Bakumatsu Deshima mikōkai monjo* (Tokyo: Shin-Jinbutsu Oraisha, 1992), p. 85.

6 Moeshart, p. 227.

7 Terry Bennett and Sebastian Dobson, 'The Sentarō Daguerreotype: A New Episode in Japanese

Photo-History Discovered', *The Photo Historian*, no. 117 (July 1997).

8 Francis L. Hawks, ed., *M.C. Perry: Narrative of the Expedition of an American Squadron to the China Seas and Japan, Performed in the Years 1852, 1853 and 1854* (Washington, D.C.: D. Appleton and Company, 1856), p. 407.

9 Moeshart, p. 225.

10 Archive of Kawamoto Kōmin, held in the library of the Japan Academy (Nihon Gakushiin Toshoshitsu).

11 Katagiri Kazuo, 'Satsuma Iseki to Kawamoto Kōmin no shashin satsuei seiko', *Yōgakushi kenkyū*, no. 11 (1994).

12 Ozawa, p. 17.

13 Huyssen van Kattendyke, Willem Johan Cornelis (translated by Mizuta Nobuyoshi), *Nagasaki kaigun denshūjo no hibi* (Tokyo: Heibonsha, 1964), pp. 99–100.

14 Shōkoku, ed., *Shōkoku kobunsho* (Kagoshima: Shimazu-ke Rinji Hensanjo, 1910), p. 123.

15 Julius L.C Pompe van Meerdervoort, *Vijf Jaaren in Japan*, 1866 (translated by Numata Jiro and Arase Susumu), *Nihontaizai-kenbunko* (Tokyo: Yūshodō, 1976).

16 Kumamoto Kenritsu Bijutsukan, ed., *Tomishige Shashinjo no 130-nen* (Kumamoto: Kumamoto Kenritsu Bijutsukan, 1993), p. 165.

17 Moeshart, p. 227.

18 Ogawa Teizō and Sakai Shizu, *Matsumoto Jun jiden: Nagayo Sensai jiden* (Tokyo: Heibonsha Tōyōbunko, 1980), p. 19.

19 Bauduin, Anthonius Julius (translated by Mineko Vos), *Oranda ryoji no bakumatsu ishin: Nagasaki Deshima kara no tegami* (Tokyo: Shin-Jinbutsu-Ōraisha, 1987), p. 56.

20 Sebastian Dobson informed me that Rossier's Christian name is still unknown; however, from an inscription 'P. Rossier' in a negative from one of his photographs we now know that his first initial was 'P'.

21 Matsumoto, pp. 20–22.

22 Watanabe Shinjirō 'Shashinjutsu denrai torishirabe ni kansuru shorui', part 1, *Shashin shimpō*, no. 44, 1893, p. 10.

23 Endō Masaharu: 'Shippan shashinjutsu to yōgakusha', *Yōgaku (Yōgaku shigakkai kenkyū nempō)*, vol. 2, 1994; Ozawa, pp. 50–55.

24 'Nihon shashin no kigen', part 8, *Tōyō hinode shimbun*, 15 April 1902.

25 Rutherford Alcock, *The Capital of the Tycoon: A Narrative of a Three Years' Residence in Japan,*

1863 (translated by Yamaguchi Kōsaku), *Taikun no miyako: Bakumatsu Nihon taizai-ki* (Tokyo: Iwanami Shoten, 1962), vol. 1, p. 43.

26 Thomas Clark Westfield, *The Japanese: Their Manners and Customs* (London: Photographic News Office, 1862).

27 Terry Bennett, *Early Japanese Images* (Tokyo: Charles E. Tuttle Co. Ltd., 1996), pp. 67–68 reproduces six of these images.

28 Interview with Ueno Hikoma; Suzuki Hachirō, Ozawa Takeshi, Yawata Masao and Ueno Ichirō, eds., *Shashin no kaisō: Ueno Hikoma – Shashin ni miru Bakumatsu–Meiji* (Tokyo: Sangyō–Nōritsu Tanki Daigaku Shuppanbu, 1975); Yawata Masao, *Hyōden: Ueno Hikoma – Nihon saisho no puro-kameraman* (Tokyo: Musashino Shobō, 1993); Kinoshita Naoyuki, *Ueno Hikoma to Bakumatsu no shashinka-tachi*, (Tokyo: Iwanami Shoten, 1997).

29 Ozawa., p. 170.

30 Himeno, pp. 83–87.

31 Ishiguro Keishō, *Bakumatsu–Meiji omoshiro shashin* (Tokyo: Heibonsha, 1996), p. 86.

32 Claudia Gabrielle Philipp, Dietmar Siegert and Rainer Wick (eds), *Felice Beato in Japan: Photographien zum Ende der Feudalzeit 1863–1873* (Heidelberg: Edition Braus, 1991), p. 13.

33 Gert Rosenberg, *William Burger: Ein Welt und Forschungsreisender mit der Kamera 1844–1920*, (Wien-Munchen: Christian Brandstatter, 1984).

34 *Ko-Uchida Kuichi keireki*, written by Iioka Sentarō, 9 pp. In the possession of Old Japan, U.K.

35 Ogawa and Sakai, p. 21. It is noted that Matsumoto mentions Uchida's reputation in his diary.

36 Chapter 4, 'Saikoku junko' in Kasumikaikan Shiryō-tenji-iinkai, ed., *Rokumeikan hizō shashinchō*, (Tokyo: Heibonsha, 1997).

37 Kamura Kunio and Araki Masato (eds), *Shashin-jidai no yoake – Nagasaki-ken shashin hyakunenshi* (Nagasaki: Nagasaki-ken Eigyō Shashinka Kyōkai Henshū Iinkai, 1995), pp. 226–7.

38 See the Ueno-Tomishige correspondence in Kumamoto-ken Kyōiku Iinkai [Kumamoto Prefecture Education Committee], ed., *Tomishige Shashinjo Shiryō Chōsa Hōkokusho* (*Kumamoto-ken Bunkazai Chōsa Hōkokusho 183*), (Kumamoto: Kumamoto-ken Kyoiku Iinkai, 1999), appendix, documents 1–16.

39 'Nyūmon Oboegaki' (Memorandum for disciples), in Kumamoto-ken Kyōiku Iinkai (ed), p. 204.

40 *Tōyō Hinode Shimbun*, no. 89, 22 April 1902.

41 Kamura and Araki, p. 50.

42 Kumamoto-ken Kyōiku Iinkai, ed., pp. 198–9.

'I BEEN TO KEEP UP MY POSITION'

Felice Beato in Japan, 1863–1877

Sebastian Dobson

With his eccentrically phrased English, colourful Levantine background and flamboyant personality, the photographer Felice Beato (1834–c.1900) (fig. 1) was one of Queen Victoria's more exotic subjects, and remains one of the most engaging figures in the history of photography. When he established a photographic studio in Yokohama in 1863, Beato was at the height of his creativity. Uniquely among western photographers in Japan at that time, he already boasted an impressive track record as a commercial photographer, having chronicled the aftermath of the Crimean War in 1855, the Indian Mutiny in 1858 and the Second Opium War in China in 1860.

During the remainder of the 1860s, and well into the following decade, Beato enjoyed a well-deserved reputation as the premier photographer of Japan, and his most active period as a photographer coincided with the tumultuous changes in Japan which followed the opening of the country to the outside world in the 1850s and led to the overthrow of the Shogunal government in 1868. Japan continued to interest Beato even after he withdrew from photography altogether and sold his studio to Baron Raimund von Stillfried in 1877, for he chose to make his home there until bankruptcy obliged him to leave Yokohama in November 1884 and seek new opportunities in London, the Sudan and finally Burma. Japan represents an important chapter in Beato's life: during a lifetime of frequent drifting between his birthplace in Corfu and his probable final resting place in Burma, the two

Fig. 1 Unidentified photographer, *Portrait of Felice Beato*, c.1872. Author's Collection.

decades which Beato spent in Japan were the longest period in his life in which he stayed continuously in the same place. In this paper, I would like to complement what has already been written on Beato and examine the impact which Japan had on his development as a photographer.[1]

Before turning to Beato's arrival in Japan, however, it may be appropriate to mention that the often vexed question of his ancestry and age can now be definitely resolved. Lengthy

research by John Clark, John Fraser and Colin Osman established the likelihood that Beato was a native of Corfu, which, as part of the Ionian Islands, had been ceded to Britain in 1814, and would therefore have qualified him as a British subject. His date of birth was estimated variously as 1825 or 1834. A newly discovered document in the archives of the

saint of Corfu is Saint Spiridion and most male inhabitants of the island are named in honour of the saint, even to this day, suggest that Wirgman was well aware of his friend's origins. Even the 'Policastro' referred to in Beato's satirical title may be another reference to Corfu, through an Italianisation of the popular Corfiote beauty spot of Palaiokastritsa.

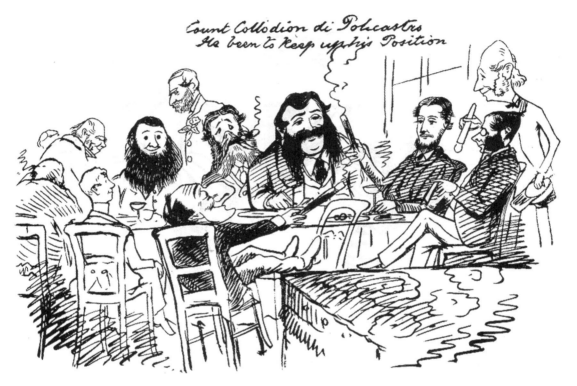

Fig. 2 Felice Beato in his cartoon guise as 'Count Collodion di Policastro'. *The Japan Punch*, January 1869 (Yūshōdō Co., Ltd).

India Office provides rare official confirmation of both details. A travel permit issued to Beato and his two servants at Fort William on 16 March 1858, gives his age as 24 and his birthplace as Corfu.[2] This explains one of the nicknames bestowed on Beato in the pages of the *Japan Punch* by his friend Charles Wirgman, who in addition to referring to him as 'Count Collodion di Policastro' (fig. 2) also used the name 'Spiridion'. That the patron

In any case, it is a remarkable coincidence that two of the best-known nineteenth-century interpreters of Japan, Felice Beato and Lafcadio Hearn – the one as a photographer, the other as a writer – were born within less than 100 miles of one another.

Japan – a new approach for Beato?
While Beato's Japanese portfolio has been surveyed in some detail, the question of how

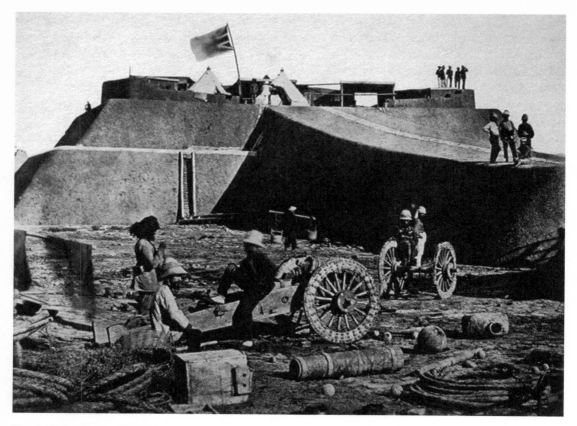

Fig. 3 Felice Beato, 'Head Quarter Staff – Pehtang Fort', China, August 1860. Michael and Jane Wilson Collection.

far Japan affected his development as a photographer has never been fully addressed. There can be little doubt that Japan marked a turning point in Beato's output, for whereas his previous work in the Crimea, India and China had underlined and even celebrated conflict and the triumph of British imperial might, Japan was one of the few non-European countries to remain outside the orbit of Western imperialism, and as such it required a new approach. Ironically, this watershed became most apparent in September 1864 when Beato reprised his previous role as an official documenter of British military strength and accompanied a multinational punitive expedition to Shimonoseki, where the Chōshū clan had closed the Kammon straits to foreign shipping. The campaign was short and successful, and Beato's most memorable image

of the action, a study of British marines and sailors occupying a Chōshū gun battery (fig. 3), proved so popular that it was reproduced a few months later as a woodcut engraving on the front cover of *The Illustrated London News* – paradoxically it was the Christmas Eve issue – the first and only occasion that a photograph by Beato merited this format.[3]

Nevertheless, this and other images taken during the Shimonoseki campaign are oddly different to those which Beato had taken in India and China several years before. Although the mood of triumph is rendered unmistakable by the confident swagger of the members of the naval landing party, with the Union Flag raised above the battery, and, more ominously, the smoke from a burning village visible in the distance (fig. 4), there is little sense of place. Furthermore, the defeated enemy is strangely

Fig. 4 Felice Beato, British naval landing party in the Maedamura Battery, Shimonoseki, 6 September 1864. Michael and Jane Wilson Collection.

absent, and Beato seems to have eschewed in this instance the gruesome compositions based on the placing of enemy corpses which he had practised in India and perfected in China, and on which his reputation as a war photographer was based.[4]

There were certainly enemy dead at Shimonoseki – the diplomat Ernest Satow, who was with Beato during the action recalled seeing small groups of Japanese corpses, with the enemy dead totalling around twenty, and yet Beato did not photograph them. Similarly, the exotic debris left by the enemy – which, during the Second Opium War, Beato had employed most effectively in his views of the occupied Taku Forts – is also absent from the photographs, although, according to Satow, the ground was littered with 'armour, bows and arrows, spears and swords' with which,

presumably, some composition could have been made. Indeed the only Japanese objects visible in Beato's Japanese battlefield studies are western-style heavy artillery which had been cast in Edo only ten years before. When, in 1871, Beato was employed as a war photographer during the United States naval expedition to Korea, the characteristic elements of exotic enemy dead, abandoned archaic weaponry and triumphant representatives of western armed force would appear again in his portfolio. Japan, however, provides an interesting exception to an otherwise consistent approach by Beato to the representation of war. Could it be that there was something different in having the Japanese as adversaries?

One important factor which is often ignored in studies of Beato is that the situation

33

he encountered in Japan was different to that he had previously experienced in India and China, for, whereas the presence of westerners in those countries was taken for granted – the former being a British colony, and the latter a patchwork of European colonies and spheres of influence – Japan was an independent nation which was seeking to open up to the west on

Fig. 5 Felice Beato, View of the Kurume and Akizuki Clan *yashiki*, Edo, ca.1863. Michael and Jane Wilson Collection.

her own terms. Westerners in Japan were there under sufferance and – with the exception of the Shimonseki campaign – their movements largely restricted to the treaty ports opened in 1859. In his study of Beato's views of China, David Harris writes:

> In the majority of the photographs that Beato made of Canton and Beijing, the Chinese are largely absent and their culture is represented by the mute presence of their architecture. When the Chinese do occasionally figure, they are shown seated in doorways…, on steps…, or leaning against the ancient walls… They occupy a passive and incidental position, hovering at the edges…, or because of lengthy exposures, they are reduced to an indistinct blur in the background… In contrast, the British,

including Charles Wirgman… and Beato himself… are found at the centers [sic] of the photographs, exuding self-assurance and control.[5]

A comparison with Beato's Japanese landscapes reveals less of a passive and peripheral position on the part of the inhabitants. Perhaps the most atmospheric of his landscape photographs are the views of the clan residences at Tsunazaka in Edo (figs. 5 and 6), which are usually found in Beato's albums with the titles 'Satsuma's Palace, Yedo' and 'Palace of Arima-Sama – Yedo'. In both views, it is the Japanese figures which seem to possess self-assurance and control; indeed, there is almost an air of menace, reminding the contemporary viewer that Edo was normally closed to foreign visitors, and that those who did go to the Shogun's capital required an official Japanese escort for their own protection. Instead of recording these scenes as the confident representative of British imperial power, Beato had to rely on subterfuge in order to take them, as one of his travelling companions recalled during a visit to Edo in 1863:

> On our right extended the magnificent shade of the park of the Prince of

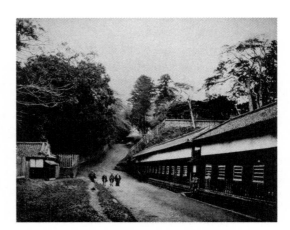

Fig. 6 Felice Beato, View of the Shimabara Clan *yashiki*, Edo, c.1863. Michael and Jane Wilson Collection.

Fig. 7 Felice Beato, View of the Site of the Kamakura Murders, Kamakura, November 1864. Courtesy of David Newman.

Satsuma… on our left the wall of enclosure of a palace of the Prince of Arima… Mr. Beato set to work to procure a photograph of this peaceful picture when two officers of the prince hastily approached him, and insisted he should desist from the operation. Metman [the group's interpreter] begged them to go first and ascertain the commands of their master… Returning in a few minutes, they declared that the Prince absolutely refused to permit that any view whatever of his palace should be taken. Beato bowed respectfully, and ordered the porters to carry away the instrument. The officers withdrew, satisfied, not suspecting that the artist had time to expose two negatives during their absence. The guards of the escort, impassive witnesses of the scene, were unanimous in applauding the success of the stratagem.[6]

In contrast, on the rare occasions that westerners do appear in Beato's Japanese

landscapes, it is usually they who are incidental to the subject. In Beato's views of Kamakura, figures identifiable as the photographer and his friend Wirgman are shown seated to one side, while groups of Japanese occupy a central position. British military and naval officers on an excursion with Beato inside the Yokohama treaty limits appear in some views of Iiyama and Miyagase but they do not dominate the scene, and they are always accompanied by Japanese. The only scenes where Westerners consciously occupy centre stage – with the obvious exception of Beato's photographs of the captured enemy batteries at Shimonoseki – are a pair taken in November 1864 at a spot in Kamakura near the main approach to Hachiman Shrine. This was the site of the horrific murder of Major Baldwin and Lieutenant Bird of the 20th Regiment of Foot, then serving in the British garrison in Yokohama, and the episode was a reminder of the vulnerability of the foreign community to attack from anti-foreign zealots. The Kamakura Murders had a particular

poignancy for Beato since not only had he had breakfast with the two officers that same morning, and was therefore one of the last people to see them alive, but he had also narrowly avoided the same fate when he declined the invitation to join them on their excursion to Kamakura. Beato appears to have taken these views of the scene of the murder shortly after it occurred, and he succeeded in conveying a sense of the shock and unease which had gripped the foreign community: 'more easily imagined than described', according to Satow (fig. 7).[7] In these photographs, the westerners seem to lack the self-assurance and control so characteristic of the figures in Beato's Chinese landscapes of four years before.

However, the most obvious change in Beato's output after establishing himself in Yokohama was the development of an extensive portfolio of portrait studies of Japanese subjects. Hitherto, Beato's portrait work had supplemented his documentation of the Indian Mutiny and the Second Opium War, and in its representation of local inhabitants not only echoed the inequality of power implicit in the imperial relationship, but was also limited in subject matter. The only portraits of a non-European to be issued as part of Beato's China portfolio were those of the Emperor's brother, Prince Kung, who had signed the Convention of Peking in November 1860 (fig. 8).

In Japan, on the other hand, Beato studiously photographed members of almost every social rank. A rare surviving album purchased from Beato's studio in December 1863 indicates that within only several months of his arrival in Yokohama Beato was taking portraits of various local 'types', including tea house girls, samurai officials, and Buddhist priests.[8] Over the next few years, the portfolio would include representatives of each of the four social levels of Tokugawa Japan – warriors (*shi*), farmers (*nō*), artisans (*kō*) and merchants (*shō*) – and many who belonged to none of these categories, such as courtesans, street performers, mendicant priests and labourers. The portrait work produced by Beato both before and after the great fire of Yokohama of 26 November 1866 is essentially documentary in style, and is totally lacking in condescension towards his subjects. Although he suffered a major setback with the loss not only of his negatives but also his studio in the 1866 fire, Beato appears to have taken advantage of this opportunity to improve on his original portfolio of so-called 'Native Types', and the later portraits which feature in the lavish albums he issued in 1868 are highly accomplished in execution.

Nevertheless, one of the most striking portraits taken by Beato comes from his pre-1866 portfolio, which may explain its relative rarity. It is a study of four samurai of the

Fig. 8 Felice Beato, Portrait of Prince Kung, Peking, November 1860. Michael and Jane Wilson Collection.

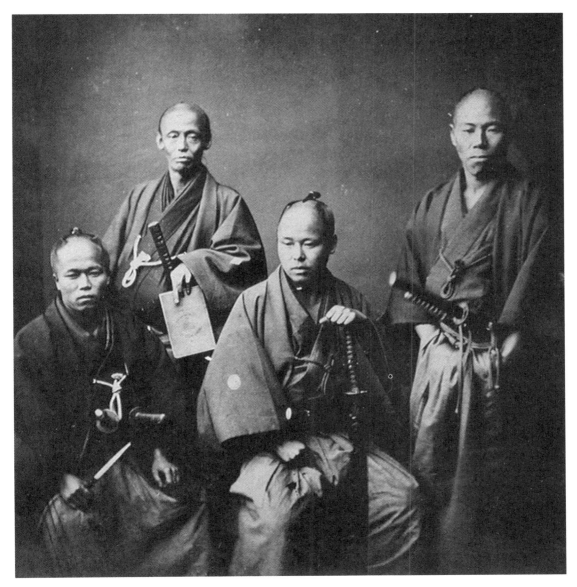

Fig. 9 Felice Beato, Portrait of the Satsuma Clan Envoys, Yokohama, November 1863. Michael & Jane Wilson Collection.

Satsuma clan who came to Yokohama in December 1863 as official envoys of their lord (fig. 9). The group, headed by Iwashita Sajiemon, was entrusted to negotiate an indemnity with the British legation for the murder of the English merchant, Charles Richardson, in September of the previous year – as well as to normalise relations between their clan and Britain, with whom they were still nominally at war following the bombardment of the Satsuma capital, Kagoshima, by the Royal Navy in August 1863. In contrast to the portraits of Prince Kung which Beato had taken over three years before, those of Iwashita and his party appear to have been taken on their own terms. A mood of defiance is evident: two of the party stare directly at the camera, and one of them stands with his hands thrust deep into his pockets. The oldest envoy, probably Iwashita himself,

gingerly holds a book in a western-style binding – unfortunately the text on the front cover is indecipherable, perhaps it is a dictionary or scientific manual, providing mute testament to the Satsuma clan's familiarity with western learning. It is a politically charged portrait, and would have done much to disturb the Treaty Port mentality of the time which seemed to equate photographing an exotic Asian adversary with the triumph of the west's civilising mission in the Far East.[9] Unlike Prince Kung, however, the Satsuma envoys were negotiating from a far more ambiguous position, for the Royal Navy's bombardment of Kagoshima had ended inconclusively, leaving both sides in a position to claim a victory.

The subsequent negotiations in Yokohama involved face-saving measures to settle the Anglo-Satsuma dispute. In particular, the Satsuma envoys agreed to pay an indemnity, which they cleverly borrowed from the Shogunal treasury with no intention of ever paying back, while the British chargé d'affaires accepted an assurance from Iwashita that an attempt would be made to find and punish Richardson's murderers – a measure which the Satsuma authorities had no intention of undertaking, and the British had no intention of pressing. Considered against this background, Beato's photograph of the Satsuma envoys possesses not only artistic merit as a portrait but also documentary value in chronicling the ambiguity of Japan's position towards the west – and vice versa – in the first decade of renewed contact between the two.

The landscapes and portraits which Beato produced between 1863 and 1870 represent the first significant body of photographs taken by a western photographer living and working in Japan, and one with which both Japanese and westerners were familiar. In terms of Beato's development as a photographer, Japan represented the stage in his career when he was at the height of his powers. The history of

photography not only in Japan but in its wider context is all the more richer as a result of this important artistic encounter.

Notes

1 The revised version of the chronology of Beato by John Clark, John Fraser and Colin Osman in John Clark, *Japanese Exchanges in Art, 1850s–1930s, with Britain, Continental Europe and the USA: Papers and Research Materials* (Sydney: Power Publications, 2001), remains the most comprehensive collection of material relating to all aspects of Beato's life and career. Probably the best survey of Beato's Japanese portfolio is the exhibition catalogue published by the Yokohama Archives of History: Saito Takio, ed., *F. Beato Bakumatsu Nihon shashinshū* (Yokohama: Yokohama Kaiko Shiryōkan, 1987).

2 Record Book, 'India. Political Consultations, 19 March–9 April 1858', p. 202–49, no. 244. India Office Archives, The British Library, London.

3 Probably through the agency of his friend, Charles Wirgman, photographs by Beato, including a panoramic view of Edo, had appeared as engravings in *The Illustrated London News* since 1864, and continued to appear until 1866, but none were reproduced on the front cover.

4 David Harris, *Of Battle and Beauty: Felice Beato's Photographs of China* (Santa Barbara: Santa Barbara Museum of Art, 1999). In particular, see the author's essay 'Imperial Ideology and Felice Beato's Photographs of the Second Opium War in China', pp.15–41.

5 Harris, p. 27.

6 Aimé Humbert, *Le Japon Illustré*, 1870, quoted in Clark Worswick, *Japan: Photographs 1854–1905* (New York: Pennick Publishing, 1979), pp.132–33.

7 Sir Ernest Satow, *A Diplomat in Japan: An Inner History of the Japanese Reformation* (London: Seeley Service, 1921), p. 135.

8 The album, which was acquired by Lieutenant Alexander Douglas of *HMS Encounter* and is dated in his hand 20 December 1863, is held in the library of The Japan Society, London.

9 A particularly relevant expression of this attitude appeared in an article in the Hong Kong newspaper *The China Mail* in November 1864, describing Japan's apparent softening towards the west: '… the last we heard of the once terrible [Prince of] Satsuma was that he had just been seen

sitting in a photographer's studio, with a camera in
front of him and the photographer's head under a
cloth. Of course, if the master shows such good
feeling towards us, the men follow suit...' *The
China Mail*, 10 November 1864, pp.173–74. The
author was evidently unaware of the pioneering role
played by the Satsuma clan in developing
photography in Japan, and the fact that the
predecessor of 'the once terrible Satsuma', Shimazu
Nariakira, had had his portrait taken by clan
scholars in September 1857. I am indebted to the
independent scholar Régine Thiriez for sharing this
reference with me.

CHANGING VIEWS

The Early Topographical Photographs
of Stillfried & Company

Luke Gartlan

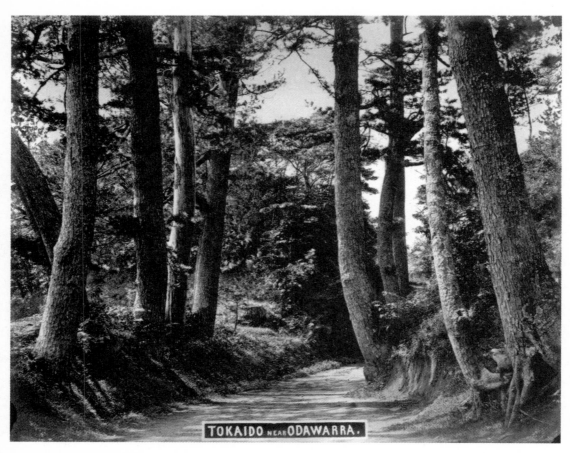

Fig. 1 Baron Raimund von Stillfried, *Tokaido near Odawarra*, 1871, 23.0 x 28.5 cm, untinted albumen print. *Views and Costumes of Japan*, Stillfried & Company, vol. 1, print 24. Metropolitan Museum of Art, New York.

Among the many Central European photographers active in nineteenth-century Japan, Baron Raimund von Stillfried-Ratenicz (1839–1911) occupies a pre-eminent position.[1] Throughout the 1870s, he managed a series of prominent studios in Yokohama, marketing his finely crafted albums primarily to the thousands of foreign tourists en route around the world. Returning to their homelands, these patrons displayed their photographic souvenirs to family and friends, and in some cases employed the images to illustrate their own travelogues, magazine articles and ethnographic studies. In so doing, Stillfried not

only fulfilled the tourist market for commemorative depictions of Japan, but helped shape the late-nineteenth-century perception of Japanese society in both popular and erudite foreign discourses. At the height of his fame, Stillfried could boast of employing 38 full-time Japanese assistants in the production of his merchandise,[2] placing his firm alongside some of the period's most prosperous counterparts in the metropolitan centres. Yet, despite his international reputation and local influence, there are numerous major inaccuracies and omissions in the secondary literature that have resulted in a skewed understanding of his photography and studio enterprise. As one of the principal photographers of the early Meiji period, the critical reconstruction of his oeuvre and professional activities is essential to an understanding of the wider souvenir industry.

In this paper, I consider Stillfried's first outdoor portfolios within the broader cultural and professional context of the changing Yokohama photography industry. In many respects, these hitherto unattributed first efforts reveal the current limited notion of Stillfried's work. For a photographer better known for his studio-based, traditional genre subjects, it is surprising to realise his overwhelming early interest in topographical photography.[3] Given the prominence of outdoor work in Stillfried's first professional years and its general neglect as a subject of analysis, my discussion focuses on these little-known studies. More than simply a connoisseurial matter of redressing his oeuvre, Stillfried's early Japanese views testify to his professional emergence at the crossroads between a local clientele and an emerging global market, indebted to residential precedents and yet fixed in a rapidly changing milieu. While these early works formed the core of his Japanese 'views' for the remainder of the decade, Stillfried returned to outdoor photography in his later portfolios of Hong Kong (1881), Siam (1882), Bosnia-Herzegovina and Greece (1889). Considered in

their entirety, Stillfried ranks among the most accomplished and patently underrated topographical photographers of the late nineteenth century.

Unlike the monumental Himalayan scenes of Samuel Bourne, or John Thomson's grand vistas of China, Stillfried brought an intimacy to his views of wooded paths, mountain villages, and secluded sites that are no less impressive for their modest scope. With an adept pictorial sensibility, *Tokaido near Odawarra* (fig. 1) explores the effects of light percolating through the foliage and the dappled patterns rendered across the pathway.[4] Like the Barbizon painters and their photographic interpreters, Stillfried could find inspiration in the turn of a quiet, tree-lined road, removed from the tensions of the industrialised world. However, such rustic views do not preclude other representations of Japan that undermine the notion of a Far Eastern Arcadia beyond the discontents of modernity.[5]

In a few critical photographs, Stillfried included signs of Japanese modernisation – the appearance of foreign-style garments, bowler hats, and gas lighting – that acknowledged the rapid changes occurring in the country without any of the virulent criticism that characterised much foreign commentary.[6] In his photograph *Choin* (fig. 2), the site of a renowned Buddhist monastery in Kyoto, Stillfried depicts a broad avenue equipped with a row of foreign-style lamp posts. Although the inclusion of an indigenous bystander adheres to the conventions of picturesque photography, foreign operators beyond the treaty port limits rarely depicted signs of Japanese modernisation. Yet Stillfried did not present such elements for their own sake, but as simple facts of contemporary Japan, neither deserved of particular attention nor avoided as unauthentic.

This point is further illustrated in *Kitano* (fig. 3), comprising six Japanese bystanders in various attitudes. Instead of recording a pre-industrial people destined to vanish before the advance of modernity, Stillfried's casual

Fig. 2 Baron Raimund von Stillfried, *Choin*, May 1872, 22.9 x 28.4 cm, untinted albumen print. *Views and Costumes of Japan*, Stillfried & Company, vol. 2, print 74. Metropolitan Museum of Art, New York.

inclusion of a few bystanders dressed in foreign-style garments, including one seated figure on the right in high leather boots, a bowler hat, and holding an imported umbrella, introduces an element of cultural transformation that acknowledges an everyday indigenous dialogue with the wider world.[7] In the co-existence of traditional and modern cultural aspects, these early views reflect the experiences of long-term foreign residents in Japan, presenting an image of Japanese society that is not necessarily consistent with the dominant discourses circulating in the metropolitan centres. As the tourist market asserted its primacy, however, Stillfried altered and selected his early negatives to reflect the changing demand for scenes unsullied by

foreign influence. Nevertheless, Stillfried's initial willingness to admit signs of cultural exchange in his practice underscores his personal, long-term experience of his adopted country.

First portfolios, 1871–72
By virtue of its early date and content, one of the foremost examples of Baron Stillfried's work is the two-volume album of photographs preserved in the Metropolitan Museum of Art, New York, bearing the frontispiece title *Views and Costumes of Japan* (fig. 4).[8] Apart from the twentieth-century binding, the landscape-format volumes are in superb condition, each containing 50 albumen photographs of an exceptional print quality. According to the

Fig. 3 Baron Raimund von Stillfried, *Kitano*, May 1872, 22.7 x 28.7 cm, untinted albumen print. *Views and Costumes of Japan*, Stillfried & Company, vol. 2, print 82. Metropolitan Museum of Art, New York.

Fig. 4 Baron Raimund von Stillfried, Frontispiece to *Views and Costumes of Japan*, Stillfried & Company, 1872, 22.9 x 28.6. Metropolitan Museum of Art, New York.

museum records, these volumes were first presented to the American missionary, Samuel Robbins Brown, by the Union Church of Yokohama for his service in the port's formative years.[9] While the first ten photographs, measuring approximately 19 x 24 cm, present a selection of exquisite hand-tinted genre scenes, the remaining 90 untinted prints, in most cases roughly 23 x 29 cm, depict views and sites in the Yokohama and Tokyo regions as well as Osaka, Kyoto, and Nagasaki (figs. 1–3).[10] To my knowledge, this album is the only surviving example to contain the title page of Stillfried's first studio at No. 61, Main Street, Yokohama, opened in the summer of 1871.[11] Stillfried remained at this address for no more than 18 months before relocating to No.

59, Main Street, by the beginning of 1873.[12] Yet despite its importance as a representative sample of Stillfried's earliest professional work, these two volumes have yet to receive even the most perfunctory academic consideration.

On the basis of the Brown album, a number of unattributed collections in the Bibliothèque Nationale, Paris, and in the possession of private collectors in New York and Bern, Switzerland, comprising respectively 65, 38, and 14 prints, have been identified for the first time.[13] Not only are there many duplicate prints common to these four collections, but the views

sufficient corpus to assess the photographer's early achievement.

With the reconstruction of this portfolio, it has become apparent that photographs such as *Tokaido near Odawarra*, *Tokaido near Imoto*, and *Imoto* (fig. 6), bearing the distinctive black and white title, constitute part of Stillfried's inaugural series compiled in the summer of 1871.[14] With a few exceptions, these views are confined to sites readily accessible and popular among Yokohama residents, including the principal attractions of Tokyo and the sites encountered on the well-travelled excursion

Fig. 5 Baron Raimund von Stillfried, *Tokaido near Imoto*, 1871, 23.0 x 29.0 cm, untinted albumen print. Bibliothèque Nationale, Paris.

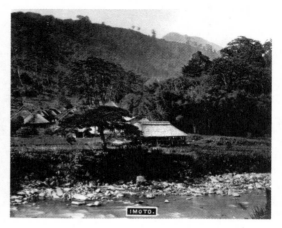

Fig. 6 Baron Raimund von Stillfried, *Imoto*, 1871, 23.0 x 28.7 cm, untinted albumen print. *Views and Costumes of Japan*, Stillfried & Company, vol. 1, print 29. Metropolitan Museum of Art, New York.

also share the two types of caption evident in the Brown album (figs. 5, 9). Hence, while *Tokaido near Imoto* (fig. 5) is absent from the Brown album, one can attribute the work on the basis of the distinctive caption. Another feature common to these portfolios is a red ink border, in all cases except the small Bern album, framing each print on the mounting. By cross-referencing these scattered collections, the total register from the No. 61 studio currently numbers more than 150 photographs. This is a figure that will certainly rise as more albums reappear from archives around the world, however, the current compilation provides a

route into the Hakone mountains.[15] In such evocative studies as *Tokaido near Imoto*, with its winding tree-lined path on the left and the atmospheric fields on the right, Stillfried demonstrates his consummate handling of spatial recession. Through his careful selection of the vantage point and framing, he employs the strong vertical lines of the foreground trees to divide the scene into two sections. In stark contrast to the open expanses on the right, the twisted canopy of branches covering the upper left enclose the scene below, luring the viewer down the narrowing, serpentine path toward the thatched-roof domicile. From the beginning

of his new career, Stillfried exhibited an awareness of pictorial composition that reflects his academic art training.

If we consider the Brown album, the view section begins by charting an excursion into the Hakone Mountains. By plotting the print order onto a map of the region, one notes that the album documents the sites and towns encountered en route to the popular mountain resort of Miyanoshita. But while the photographs depict the various sites, it is the experience of trekking and sightseeing that constitutes the portfolio's underlying subject of analysis.

for the foreign community, affirms the destination awaiting the traveller in the distant hills.[16] It is for this reason that the road occupies such a prominent place in these photographs, with the camera position reiterating a traveller's viewpoint of the route ahead.

Following this series, the album turns to the historic sites of Tokyo, announced with three consecutive views of the city.[17] With only a few exceptions, three famous locations dominate this section of the album: the Shiba Park temple complex (prints 41–45), the Imperial Palace (prints 47–50), and the Asakusa

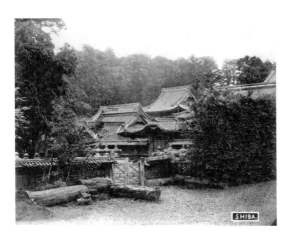

Fig. 7 Baron Raimund von Stillfried, *Shiba*, 1871, 23.2 x 28.8 cm, untinted albumen print. *Views and Costumes of Japan*, Stillfried & Company, vol. 1, print 41. Metropolitan Museum of Art, New York.

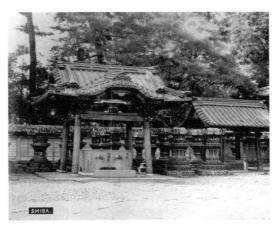

Fig. 8 Baron Raimund von Stillfried, *Shiba*, 1871, 22.7 x 28.9 cm, untinted albumen print. *Views and Costumes of Japan*, Stillfried & Company, vol. 1, print 45. Metropolitan Museum of Art, New York.

Although as single photographs this aspect of the portfolio remains indistinct, the album presents a carefully orchestrated sequence that narrates an excursion into the Japanese hinterland. This trajectory is further enhanced by such studies as *Tokaido near Odawarra* and *Tokaido near Imoto*, where the title serves to link the view to the next print, invariably depicting the mentioned village. Interspersed among the principal sites, these views highlight the excursionist's transitory experience of the countryside. That the final photograph in the sequence depicts the tea house at Miyanoshita, a popular alpine retreat

temple (vol. 2, prints 52–54). Gathered sequentially in the album, these photographs constitute a pictorial inquiry into each site's architectural qualities that invite analysis within the context of the group. A brief discussion of the five photographs depicting the Shiba temple complex suffices to illustrate this point. The first view from outside the perimeter walls, overlooking the temple roofs encircled by dense foliage, exemplifies the photographer's concern for the initial impression gained on approaching a site (fig. 7). Stillfried revels in the geometrical play of intersecting planes nestled at the centre of the

composition among the encroaching sylvan terrain. Turning the album pages, the following two photographs bring the viewer within the complex, revealing open courtyards that are barely suggested by the first external scene. In the final two photographs (and others in the smaller collections), Stillfried depicts particular architectural sections of the site that are difficult to place within the overall layout (fig. 8). Thus, Stillfried's working method effectively surveyed a complex, retracing the imagined visitor's encounter with the buildings from the general to the specific. The viewer encounters a site among the woods, enters the courtyard, before finally considering the architectural elements at closer hand.

In the final 45 prints, Stillfried abandoned the rather obtrusive black and white titles for the simple caption of *Choin*, *Kitano* and *Nagasaki* (fig. 9). The vast majority of these photographs were compiled in the second year of operations on his visit to Kobe and Nagasaki in May–June 1872.[18] En route, Stillfried took advantage of the temporary permission granted foreigners to visit Kyoto for the domestic exhibition then in progress, furnishing him with the opportunity to expand his catalogue with scenes of the historic inland city and other sites encountered during the overland journey.[19] Since Choin-in Temple was the site of the exhibition grounds,[20] Stillfried's photograph of the gas-lit boulevard almost certainly depicts a feature installed in preparation for the expected influx of foreign visitors. Later in the year, from October 4 to December 3, Stillfried continued his travels to the northern island of Hokkaidō, returning with a large portfolio of views and genre photographs of the Ainu people.[21] Since the Brown volumes do not contain any photographs from Hokkaidō, we can date this album to the period from June to October 1872, between his return from Nagasaki and departure for Hakodate.

Although few contemporary assessments of Stillfried's early photography are known, there is one important source that raises several issues. On October 16, 1871, the first review of Stillfried's work appeared in the Yokohama magazine *The Far East* under the title 'Photographic Views of Messrs. Stillfried & Co.' The informed critic, almost certainly the journal editor and keen amateur photographer John Reddie Black, provides a valuable insight into the aesthetic, technical, and commercial aspects of Stillfried's first portfolio and his studio operations.[22] Since the range of sites detailed in the review correlates with those photographs bearing the black and white captions, it seems certain that the account refers to these long-neglected images. As the only known account of Stillfried's first portfolio, the review merits quotation in its entirety:

We have been most agreeably occupied in looking over the new Photographic Album of Messrs. Stillfried & Co. As yet the range of country over which they have been taken, is confined to two routes, now commonly taken by foreigners: – by Kanasawa, Kamakura, Kataseh, Fujisawa and Odawara to Maianoshta and Hakone; and the Yedo road, the city and suburbs. Many of the pictures are particularly nice; and the points of view well and tastefully chosen. The subjects are by no means hackneyed either; for although as a matter of course, the old standards – Kamakura, the Shiba Temples and some equally familiar views, are amongst them, there are some, which to those who have any knowledge of the history of the country are fully as interesting. Such is Odawara Castle: a fortress now fast succumbing to the inroads of time, but which played a very important part in the early days of the last dynasty of Shogoons, and when Yedo was but beginning to assume any importance. The views too amongst the mountains are excellent and numerous. We do not pretend to say that all the views have equal merit. This would be absurd.

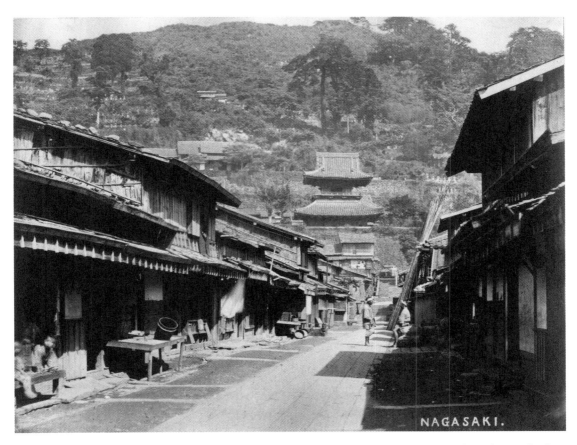

Fig. 9 Baron Raimund von Stillfried, *Nagasaki*, May 1872, 23.0 x 29.0 cm, untinted albumen print. Private collection, New York.

Allowances will be made by all who have any acquaintance with photography for the circumstances under which pictures are taken – sometimes in dull, sometimes in windy, and even as it has happened, sometimes in rainy weather. The practised eye distinguishes at once the various conditions; but the uninitiated only see what it is necessary for them to see – which pictures please them best, and are fittest for their own albums. We therefore recommend all who would like to possess some good views of the surrounding country, to pay a visit to Messrs. Stillfried & Co.'s studio – look through his Album, and select for themselves. There are pictures to suit the taste of all; and as we have said, many of great excellence.[23]

This review confirms Stillfried's primary concern with landscape photography at the onset of his new career, and the restricted scope of his wanderings to regional sites long visited by Yokohama residents hoping to escape the summer heat in the mountains or enjoy a short excursion. It reveals that a customer could either purchase ready prepared albums or select photographs for inclusion in their own compilations according to their individual needs and preferences. As a consequence of this policy, each album reflects the personal interests and experiences of the original compiler. It is far from incidental that the views in each of the three extant albums begin with Yokohama, the main port of entry for foreigners to Japan. However, the selection, order, and number of prints thereafter varies

according to the collector's personal experiences. Black also indicates that many of the sites, designated 'the old standards', had already attracted the attention of other photographers. The value of Stillfried's photographs reside not in their thematic novelty, but the aesthetic rendering, 'the points of view well and tastefully chosen,' of conventional subjects. Within the broader context of a local photographic tradition, what role did these models play in Stillfried's professional development? As the critic suggests, this question extends beyond the possible visual models to a consideration of his technical instruction.

As the earliest known sample of his work, the exceptional results attest to Stillfried's competence in the demanding glass plate collodion process from the beginning of his professional career. Introduced at the Great London Exhibition of 1851, Frederick Scott Archer's collodion process was the most prevalent method employed in nineteenth-century Japan. Although the process required the immediate preparation of the glass negative after exposure, necessitating the conveyance of bulky equipment on excursions, the photographer could reproduce numerous prints from a single negative even decades after the initial development. Notwithstanding the employment of coolies to carry the cumbersome equipment, the problems associated with the technical imperative to develop the glass negative and the difficulties faced by the variable weather conditions could challenge even the most seasoned professionals. With the expert admiration of a fellow practitioner, Black acknowledges the environmental hindrances that plague all outdoor photographers, and Stillfried's general success in handling these problems. Only on occasion, such as in the blurred background foliage of *Imoto* (fig. 6), are the tell-tale signs of gusty conditions apparent.

In view of these major obstacles facing the uninitiated photographer, Stillfried's early mastery raises the central question of his instruction. That his topographical photography demonstrates not only a technical precision but an adept visual experimentation with vertical and horizontal structures, asymmetry, depth, and other pictorial concerns suggests that Stillfried was already an astute exponent of the medium. How are we to account for these adept first products? Where did Stillfried acquire, not only his technical competence, but an impressive visual nomenclature for his depiction of Japanese subjects? While the Brown album demonstrates the sensibility of a Central European sophisticate schooled in the aesthetics of pictorial composition, an adequate response to this question must acknowledge the contribution to his professional development of several influential photographers in Japan.

A resident photographer

Unlike the majority of nineteenth-century European travel photographers, Stillfried did not leave his homeland a professional practitioner, but rather first adopted the pastime in Yokohama. No conclusive documentation has emerged to suggest a prior technical knowledge of photography, or even a casual interest, before his residence in Japan. The available evidence suggests that he first took up the camera in Yokohama, inspired by the pioneering example of several resident photographers and the commercial opportunities arising from the burgeoning tourist market. In his early portfolios, Stillfried discloses his professional lineage and debt to these local predecessors, whilst already pointing toward a photographic style rooted in his artistic training and upbringing that brought a refined aesthetic vocabulary to established themes.

Although the precise date of Stillfried's first arrival in Japan remains uncertain, some sources claim that he met the Berlin landscape painter Eduard Hildebrandt (1818–1868) in Nagasaki during the latter's tour around the world.[24] Since Hildebrandt left Nagasaki on September 22, 1863, en route for China,[25] Stillfried presumably arrived in Japan before

this date, only eight months after resigning from the Austrian military.[26] With a foreign population consisting almost entirely of diplomats, missionaries, merchants, and vagabonds, Stillfried gained employment with the Dutch silk firm *Textor and Company* located on the historic island of Deshima.[27] This position provided not only a means of support, but also the opportunity to visit the other treaty ports on business matters. It was in Yokohama, already a nascent centre of professional photography, that Stillfried purchased three *cartes de visite* from the Yokohama studio of Charles Parker.[28] On their own terms, these studio portraits are rare examples of Parker's work, yet their family provenance also constitutes the first evidence of Stillfried's contact with the elusive British photographer. Even if Stillfried's connection to Parker was merely as a customer, these *cartes* document his earliest contact with commercial photography in Japan. Given the high print quality and the imprint on one *carte* of *C. Parker & Co. Yokohama, Japan*, Stillfried almost certainly purchased these *cartes* before his departure for Mexico in the summer of 1865.

Like Stillfried's first arrival in Japan, there is some uncertainty as to the exact date of his return. The first reliable date for his arrival in Yokohama is August 20, 1868,[29] although he possibly spent a few months in Nagasaki before continuing his journey.[30] He soon gained a modest appointment as a secretary and student interpreter in the North German legation based in Tokyo. For the next two years, he served in the Prussian consulate under the career diplomat and East Asian art collector, Max von Brandt (1835–1920).[31] In the absence of official relations between Austria-Hungary and Japan, this position granted Stillfried the privilege, restricted to the diplomatic corps, to travel beyond the designated treaty port limits. With a secure income and prominent diplomatic colleagues, Stillfried's appointment was an important stepping stone into the local community.

Throughout this period, Stillfried nonetheless continued to promote the Austro-Hungarian Empire's interests in East Asia. On August 22, 1868, two days after his arrival at Yokohama, he sent a letter to Vienna informing the Foreign Ministry of his presence in the country.[32] Over the next year, he posted several reports to the Hapsburg capital on such varied political issues as the question of religion in Japan, the protracted resistance to Meiji rule in Hokkaidō, and the influence of the British legation.[33] His reports strongly advocated the potential benefits of commercial ties between Austria-Hungary and Japan. As one of the few Hapsburg citizens in Japan, the reports provided valuable information on local events before the arrival of the inaugural Austro-Hungarian expedition to East Asia in early October 1869. Although not an official expedition member, Stillfried must have assisted the mission in some capacity during its stay in Yokohama, since he later received the Knight's Cross of the Franz Joseph Order (*das Ritterkreuz des Franz Joseph-Ordens*) '. . . in consideration for the outstanding services on the occasion of our mission to East Asia and South America. . . .'[34] Issued on March 15, 1871, the impressive double-headed eagle pendant subsequently appeared on the frontispiece of his photographic albums.

Apart from establishing diplomatic and trade relations with East Asia, the Austro-Hungarian mission also collected a vast array of materials during the three-year voyage. As part of this documentary project, the squadron included an official photographer of exceptional ability, Wilhelm Burger, and his 15-year old assistant, Michael Moser.[35] Stricken by illness on his arrival in Yokohama, Burger remained behind on the expedition's departure for South America in early November, entrusted with a commission to document various art objects beyond the expedition's financial means.[36] In addition to these studies, Burger compiled a substantial portfolio of topographical and studio genre

49

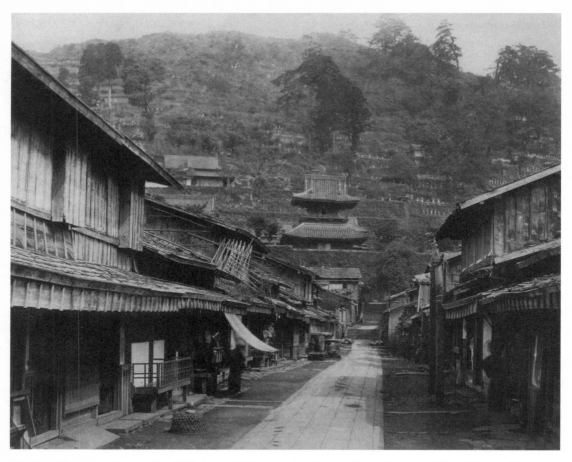

Fig. 10 Felice Beato, *Nagasaki*, c.1868, untinted albumen print. Source: Claudia Gabriele Philipp, Dietmar Siegert, and Rainer Wick (eds.), *Felice Beato in Japan: Photographien zum Ende der Feudalzeit, 1863-1873* (Munich: Edition Braus, 1991), p. 42.

photographs in various formats during his unexpectedly prolonged six-month stay in Japan. Given their shared participation in the imperial expedition and the scarcity of fellow nationals, it seems almost certain that Stillfried and Burger formed an acquaintance during the latter's stay in Japan.

Despite the lack of documentation, Burger was most likely grateful for his compatriot's local knowledge and diplomatic assistance, and his photographic activities in turn surely received Stillfried's eager attention. Although such everyday personal relations are regrettably difficult to trace, the camera often served as a social pastime among enthusiastic residents. Whatever Burger's influence before his

departure in March 1870, Stillfried abandoned his diplomatic post for a photographic venture shortly thereafter. As an early biographer noted: 'Tiring of the mundane occupation in the North German Consulate, Stillfried then became a merchant in Jeddo [Tokyo] and occupied himself with the importation of photographic goods, which at that time, because photography was greatly advancing in Japan, found a good outlet.'[37] Certainly, one could postulate numerous reasons for this career change, and Burger was perhaps only an incidental factor, but neither can his example have failed to add further impetus to Stillfried's photographic interests.

Of all the figures cited so far, however,

Stillfried incurred the greatest professional debt to Felice Beato. Long considered one of the period's most accomplished photographers, Beato played a decisive role in the nobleman's education in the difficult wet-plate collodion process. In announcing the establishment of *Stillfried & Company*, the *Hiogo News* noted on August 8, 1871: 'A new photographer has started in Yokohama, Baron STILLFRIED was once a pupil of Mr. Beato and is now trying to undersell him . . . Mr. Beato goes home next mail.'[38] As the two most influential foreign photographers active in nineteenth-century Japan, their prominence in the local industry has often invited comparison of their work. However, photo-historians have paid little attention to their professional relationship. In hindsight, Stillfried and Beato's student-teacher relation appears quite logical, yet the synergies in their practice should not efface the differences in their background, social circle, and national affiliation. Emerging from Beato's atelier, Stillfried emulated several aspects of his master's practice whilst already asserting his claim to that legacy. From the beginning, the ambitious protégé intended to supplant his master as the leading foreign photographer in Japan.

With striking semblance, Stillfried adopted many of his master's procedures for the Brown edition of *Views and Costumes of Japan*. Like the well-known Beato album in the Victoria and Albert Museum, Stillfried devised a two-volume collection of hand-tinted genre and untinted landscape work, mounted on the recto side of each leaf. Although the ratio of landscape to genre work differs, Stillfried corrected this disparity in subsequent albums as his activities shifted toward studio-based work. In addition, Stillfried's motifs often have a direct prototype in Beato's catalogue of subjects. This thematic repetition is too consistent to be merely a coincidence, indicating that Stillfried consciously plumbed his master's oeuvre for inspiration. In some cases, his views present a subtle variation on Beato's images, all but

indistinguishable if not for a few carefully placed bystanders. Among the most striking instances, Stillfried's *Nagasaki* closely resembles his mentor's depiction of the same site with only a slight change in the vantage point and framing (figs. 9, 10). Within this predetermined *mise en scène*, Stillfried places two figures in the middle distance before the steeply rising terrain. While Stillfried soon forged an independent style, his early work's debt to Beato has resulted in major errors of attribution, leading to a misconception of both photographers and their output.[39] Such accurate duplications were common in an industry that paid less heed to originality as the measure of artistic integrity than to notions of production quality and pictorial refinement. Through these careful studies, the novice learnt his trade in a manner akin to the academic copying of old masters.

By tracing Stillfried's personal contacts before embarking on his new career, my intention has not been to catalogue a list of candidates responsible for shaping his development, but to suggest his professional emergence within the context of treaty port Japan. Unlike Parker, Burger, or Beato, Stillfried did not arrive in Yokohama as a fully-fledged photographer in search of new opportunities, but shifted between a range of occupations before eventually pursuing his chosen vocation. As a consequence, Stillfried had been a resident of Japan for several years before taking to the mountains with his camera. He thus brought to his endeavour not only the principles of European landscape composition, but a local knowledge of the various sites and their popularity among other photographers. For this reason, it seems apt to consider Stillfried a resident photographer, trained within a local tradition of image making.

A resident audience

By the summer of 1871, Stillfried was able to fulfil two major criteria for the foundation of his atelier. Firstly, as an importer and distributor

of photographic equipment, he had ready access to high-quality materials from renowned overseas firms such as B.F.K. Rives, a prominent manufacturer of albumen paper.[40] Secondly, Stillfried was fortunate to receive instruction from one of the period's most accomplished photographers. With a sound technical knowledge and the requisite materials, he established *Stillfried & Company* on the premises of his assistant William Willmann.[41] As a commercial photographer entering a competitive industry, the need for a portfolio to attract customers motivated his initial activities. Yet I want to contend that the resulting collection reflects the experiences and understandings of long-term foreign residents for their adopted country, rather than gratifying a tourist desire, yet to assert its primacy, for a timeless sanctuary free from the anxieties of modernity. While Stillfried's products satisfied a foreign market for visual souvenirs of Japan, we must not homogenise this audience or the function served by such collections. It is in this respect that the Brown album occupies a pivotal position, not only as the principal document of the photographer's formative work, but also as the property of an erudite, pioneer Yokohama resident.

The Reverend Samuel Robbins Brown (1810–1880), an American missionary of the Dutch Reformed Church, was one of the first foreigners to arrive in Yokohama in November 1859 (fig. 11).[42] During his intermittent two decades in the treaty port, he published one of the first Japanese grammar texts, organised student exchanges to America, and spent several years translating the Bible into Japanese.[43] According to a posthumous biography, Brown possessed a reverence for Japan and the Japanese that extended beyond mere exotic fascination or missionary zeal: 'To him it was a privilege, a delight to work for Japan.'[44] That his parishioners deemed it appropriate to present him with a commemorative Stillfried album testifies to his high personal standing among the foreign community. While the exact date and circumstances of the presentation remain undocumented, Brown was certainly well-acquainted with Japan by the early 1870s. He therefore brought a cultural understanding and first-hand experience of the sites, customs, and histories depicted in each photograph that reached far beyond the limited knowledge of most foreign visitors.

In addition to his lengthy experience of Japan, Brown's ownership of the Stillfried album is significant because of his direct role in establishing photography in Yokohama. With the generous support of several parishes in New York State, Brown first arrived in Japan bearing a camera and its requisite paraphernalia, one of the first documented cases of the technology's presence in the treaty port. Although at first possessing little knowledge of the process, his fellow missionary Duane Simmons soon established a photographic room.[45] It was presumably with his colleague's assistance that Brown, at the age of 50, took up the pastime in the isolated port: 'Mr. Brown occupied some of his leisure and sunny hours in mastering the fascinating art of photography. He was thus one of the very first to photograph Japanese costumes, works of art, and varied human characters.'[46] Apart from providing a much-needed recreation, photography also served as a means of bridging the cultural divide with the Japanese. Equipped with the Bible and the camera, these bringers of the light employed photographic technology to attract potential converts to their mission. The best known recruit was Shimooka Renjō, the first professional Japanese photographer in Yokohama, who received instruction from the missionaries and later converted to Christianity.[47] In contrast to academic notions that stress the camera's tacit role in nineteenth-century imperial expansion and the subjugation of indigenous communities, the social use of photography could also foster cultural exchanges, even prolonged friendships, between foreign and Japanese residents that could dislodge preconceived notions and stereotypes regarding one another.[48]

Fig. 11 *Messers F. Verbeck, S.R. Brown and D.B. Simmons, c. 1860.* Source: William Elliot Griffis, *Verbeck of Japan* (Edinburgh and London: Oliphant, Anderson and Ferrier, 1901), p. 66. State Library of Victoria, Melbourne, Australia.

Brown's notable contribution to early photography in Japan and his long residency no doubt informed his assessment of the Stillfried compilation. He was well aware of the technical procedures and difficulties faced by a photographer and the preceding decade of local activity underpinning the album's production. Conversely, Stillfried's portfolio also reflects the experiences of such long-term foreign residents. Although an excursion to Shiba Park or into the Hakone mountains would feature high on the list of every globetrotter's itinerary, one must not forget that such destinations were also popular among the resident foreign community years before the advent of a tourist boom. In this respect, Reverend Brown was no exception, visiting the principal sites of Tokyo on several occasions, the scenic alpine resorts, and ascending Mount Fuji in August 1871.[49] Rather than a souvenir

of a brief excursion, the album could commemorate an oft repeated journey, familiar and cherished over many years, to the depicted sites and resorts.

For both producer and consumer, Stillfried's first portfolio operated within a foreign resident discourse that acknowledged their specific experiences of Japan. This is most apparent in the album's occasional allusions to the changing state of Japanese society that contradict the notion of a timeless, unsullied land promoted by foreign exoticist discourses. For foreign residents, the everyday changes in Japan were undeniable, particularly after the rapid modernisation instigated by the Meiji government. Arriving in the midst of these momentous events, Stillfried was an astute first-hand witness to these changes, as he later noted in an article for the Vienna World Exhibition:

> A true reformation began with the returning calm and order. Emigration was permitted, groups of Japanese travelled to Europe and America in order to learn, and then returned to their home as votaries of science; Hiogo-Osaka, Niegata and Jeddo [Tokyo] were opened to foreign trade, railways and telegraphs were built, shipworks, factories, and arsenals were established, taxation and the monetary system regulated, the army and navy reorganised, schools and institutions founded with foreign teachers, exhibitions held for agriculture, art and industry, and so on.[50]

This catalogue of policy developments and infrastructure projects denotes the revolutionary nature of the period and the writer's personal experience of their occurrence. These events would affect Stillfried's photography, firstly in his acceptance of their place in contemporary Japan, and later in his careful excision of their presence. This was a shift marked by his move from outdoor photography, where the impact of

modern technology was increasingly present, into the controlled space of the studio. It had no single cause, but resulted from the convergence of emerging market pressures, personal anxieties regarding Japanese modernisation, and the rise of competitive indigenous photographers. Before these pressures exerted their influence, however, the modernity of early Meiji Japan found expression in several of his photographs.

In the works *Choin* and *Kitano*, we have already considered two scenes that testify to the impact of modernisation on the everyday scenes in the early Meiji era. Although only a few photographs in the album exhibit such indigenous acculturation, their inclusion pervades the wider collection of picturesque scenes, suggesting the cohabitation of traditional and modern cultural systems. To consider another example, lodged between the five Shiba Park prints and the four views of the Imperial Palace toward the close of volume one, there is a view entitled *Atango-Yama* (fig. 12), a popular site overlooking Tokyo and the surrounding countryside. The image depicts the pathway leading to the above observation point, a portal, two flagpoles and several bystanders. Whereas the adjacent prints of historic sites are largely devoid of human content, this work acknowledges the sartorial intermixture apparent on the Tokyo streets. Rather than denying the Japanese fashion for bowler hats, the inclusion of such cultural adoptions acknowledges the specific circumstances of early Meiji Japan apparent to the visitor. Instead of bemoaning the replacement of

Fig. 12 Baron Raimund von Stillfried, *Atango-Yama*, 1871, 22.8 x 28.7 cm, untinted albumen print. *Views and Costumes of Japan*, Stillfried & Company, vol. 1, print 46. Metropolitan Museum of Art, New York.

traditional garments and the incursion of foreign cultural systems, these prints remain dispassionate in their portrayal of such practices, particularly in comparison to the scathing caricatures that arise in subsequent years.

Of course, not every foreign recipient of Stillfried's work commanded the kind of local experience and contacts available to Reverend Brown. Nonetheless, apart from the disassembled Bibliothèque Nationale collection, the other two extant albums support the premise of a diverse resident market. In these cases, customers selected a range of photographs to add to their own compilations. Unlike the Brown volumes, the New York album presents a more haphazard selection of 38 *Stillfried & Company* views, the occasional hand-tinted genre scene and 12 scenes from the Hokkaidō expedition. After a small number of anonymous photographs of Japan, the compilation includes two group portraits bearing the hand-written inscription '5th November 1870 to 16th July 1875. Group of Officers Royal Marine Battalion Yokohama – Japan.' Thereafter, the photographs depict the major ports encountered on the return voyage to England and numerous images of maritime vessels. This suggests that the original owner was a member of the British Marine Corps who compiled the album over several years while stationed in Yokohama.[51] In contrast, the small Bern album presents 14 views from Stillfried's inaugural portfolio charting an excursion to Miyanoshita and Tokyo. The addition of a handwritten pencil caption in French below the prints, noting a site's distance or relative position from Yokohama,[52] indicates that the francophone compiler wanted a memento of a single interior tour.

Whether American missionary, British mariner, or French-speaking sightseer, foreign recipients could select and arrange the photographic views in an album, and supplement the prints with their own notations, in order to chronicle their personal experiences of Japan. However, before the advent of a tourist

economy, Stillfried's early works addressed a diverse local marketplace. As a souvenir of Japan, Stillfried's early work reflected the particular circumstances and knowledge of long-term foreign residents in their adopted country, for whom Meiji modernisation merited remembrance alongside the scenic countryside and historic buildings. It was only in retrospect, as the tourist market came to constitute his principal audience, that Stillfried altered his stock to expunge the suggestion of regional knowledge in favour of a generalised, traditional notion of Japanese society. It is therefore not surprising that several of the views depicting Japanese modernisation are known only from a single print. Preserved in the Brown album, such works as *Kitano*, *Choin* and *Atango-Yama* would fail to find their way into subsequent albums.

Changing views: the rise of the globetrotter

> A traveller or business man who, a few years ago, went to San Francisco, Japan, China, or India, or made the circuit of the globe, arranged his affairs with the expectation that at least a year or two of his life was required to make the journey by land and water. To-day he can start from New York or London, transact important business, and enjoy the pleasures of travel, returning to his home, if desired, within the period of three months; during which time he is in communication with the chief centres of business by telegraph and steam poste-routes. – Disturnell's Railroad and Steamship Guide, 1872.[53]

Parallel to the dissemination of foreign objects, the early 1870s witnessed an influx of foreign tourists to Japan enabled by advances in international transportation and the relative security instigated by the Meiji era. With the opening of the Suez Canal and the completion of the Trans-American railway in 1869, it

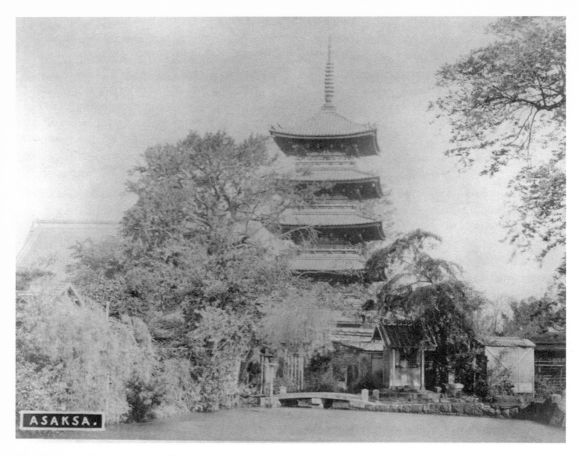

ASAKSA.

Fig. 13 Baron Raimund von Stillfried, *Asaksa*, 1871, 22.6 x 29.4 cm, untinted albumen print. *Views and Costumes of Japan*, Stillfried & Company, vol. 2, print 53. Metropolitan Museum of Art, New York.

suddenly became possible for those of moderate means to travel around the world in relative comfort and convenience. Several prominent American steamship and railroad companies published the first round-the-world guidebooks, offering package tours and allowing travellers to recommence their journey when desired.[54] Locally, the rise of the transient, leisure-seeking tourist profoundly affected the Yokohama economy, prompting the establishment of several prestigious hotels, the publication of the first European-language guidebooks to Japan, and the rise of the ubiquitous *jinrikisha* (rickshaw).[55] Indeed, the influx was so startling that the residential community coined an epithet for these transient visitors that soon gained widespread

usage throughout the anglophone world. The 'globetrotter' was a neologism that appeared in the local vocabulary to differentiate the expatriate community from these transient visitors.[56] Stillfried's decision to commence a photographic career was part of a general shift in the Yokohama economy toward the service of these newcomers.

With the arrival of such affluent visitors as Charles Appleton Longfellow and Josef von Doblhoff,[57] the excursion into the countryside became a requisite search for an authentic Japan beyond the acculturated world of the treaty ports. The split between the ports' modern world and the hinterland's pristine state was a belated discourse, a cultural remapping that fostered the tourist economy as it concurrently

subsumed resident knowledges under a deluge of globetrotter publications. The fate of Stillfried's first portfolios reflects this shift from a resident to a tourist market. By omitting those early works displaying signs of modernisation and shifting toward an almost exclusive studio-based practice, Stillfried responded to the exigencies of the globetrotter market for pre-industrial images. Furthermore, the manipulation and cropping of the original negatives to remove the title modified the contextual meaning of the views. In order to ascertain the radical nature of these changes, it is important to realise that these views brought Stillfried his first international recognition.

On January 14, 1873, Stillfried departed for Vienna accompanied by five Japanese employees on an ambitious venture to transport a seven-room teahouse to the impending World Exhibition.[58] Although the enterprise proved an unmitigated financial disaster, the exhibition brought his outdoor work to international attention for the first time, displayed and judged alongside hundreds of other photographers. By gaining the *Fortschritts-medaille* (medal for improvement) for his views of Japan,[59] Stillfried announced his arrival on the international scene as a leading topographical photographer. In an effusive review, the *Allgemeine illustrirte Weltausstellungs-Zeitung* exemplified the critical triumph of his work:

> It gives us great pleasure to be able to inform our readers that our valued colleague, Baron Raimund Stillfried, known for his photographic studio in Japan, has been awarded the medal for improvement for his 'Views of Japan', exhibited in group XII of the collective exhibition of the Austrian Photographer's Society.
>
> The novice, provided that he is endowed with artistic judgement and taste, will find it easy to recognise the merits that distinguish Stillfried's pictures.
>
> The expert however marvels at the great

technical finish of the mentioned pictures, which is all the more meritorious when one considers the difficulties under which he probably worked.

The brilliant artistic discernment, the softness of the tones, the tenderness in the details, even in the deepest sections of shadow, the vigorous and gentle transitions of light and shadow, and the clarity of the sky, are qualities that until now remain unsurpassed.[60]

With its stress on the amateur and professional audience, the reporter echoes the assessment of the *Far East*, noting the photographer's technical mastery in the presumably difficult outdoor conditions. Given such unequivocal praise of his Japanese views, Stillfried's decision to alter the negatives and become almost exclusively a studio-based photographer

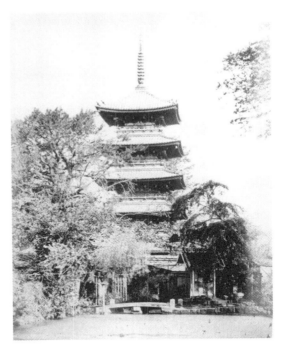

Fig. 14 Baron Raimund von Stillfried, *Pagoda à Asakusa* (third version), Sep. 1876, 23.3 x 19.2 cm, untinted albumen print. *Views and Costumes of Japan*, September 1876, No. 59, Main Street, Yokohama, print 49. Private Collection, Lille, France.

indicates a profound shift in his *modus operandi*. To alter the works that gained such unequivocal acclaim and established his reputation indicates the undeniable influence of the new tourist economy.

In the important photograph collection of the Austrian globetrotter Josef von Doblhoff, purchased in March 1874, many of the black and white titles affixed to the early views were erased and replaced with less obtrusive captions.[61] In contrast to the original print *Asaksa* (fig. 13), the Doblhoff print exhibits the blemished area left after the removal of the title (not illustrated). Yet this was not the final manipulation of the glass negative. Two and a half years later, a third print version pruned the original negative along both sides, removing

the caption altogether, and in the process transforming the photograph into a portrait format (fig. 14). In the mid-1870s, Stillfried systematically trimmed his early views of their titles to produce a generic portfolio of scenes unhindered by textual direction. Whereas Beato's albums contained long descriptive captions accompanying each photograph, providing ethnographic or historical information deemed relevant to the subject, Stillfried raised the visual to pre-eminent status over the word. After cropping the early views, Stillfried collected the titles in an index attached at the end of the albums (fig. 15).[62] The customer thus encountered a series of photographs that require interpretation according to their intrinsic pictorial aspects

Fig.15 Baron Raimund von Stillfried, *Index*, ca.1876, 20.3 x 26.0 cm, untinted albumen print with handwritten titles. *Views and Costumes of Japan*, ca.1876, No. 59, Main Street, Yokohama. Picture Collection, State Library of Victoria, Melbourne, Australia.

Fig. 16 Baron Raimund von Stillfried, *Untitled* (second version of *Tokaido near Imoto*), 1876, 19.2 x 23.6 cm, albumen print. Courtesy of the Museo Eduoardo Chiossone, Comune di Genova, Italy, *Views and Costumes of Japan* (MC/S-3269/36), print 34.

without any textual information to guide consumption. Even when the viewer ultimately encountered the index, the titles remain short and general, providing only the town, building, or geographical feature.

While this visual primacy reflects the artistic claims of Stillfried's practice, the shift also suggests the changing market expectations of the photograph album. In contrast to the limited information available to overseas audiences during the 1860s, the following decade witnessed a flood of European-language travel accounts and publications on Japan that made the need for lengthy descriptive captions less imperative. By presenting a visual compilation bereft of text, Stillfried raised his album above the fray to predicate his authority on the camera's

supposed impartial rendering of the physical world. Yet the removal of the titles often compromised the pictorial character of the views. Although the cropping of the third *Asaksa* print dramatically recast the original version, the photograph remains a balanced composition with the vertical pagoda architecture emphasised by the portrait format. Since most prints only had the lower edge cropped to remove the title, the policy had a minimal impact in most cases on the pictorial integrity of the composition. There are, however, several notable exceptions. In contrast to the aesthetic play of pictorial space and balance in *Tokaido near Imoto*, a later trimmed version appears lopsided and disproportionate, at least according to the aesthetic criteria advocated by his

contemporary reviewers (figs. 5, 16). By cropping both sides of the print, the foreground trees no longer occupy the centre of the composition, nor do they serve to divide the view into two distinct spatial sections. The trimmed portion on the right has compromised the function of the wide open fields as a pictorial counterpoint to the enclosed mountain pathway. Similarly, the cropped trees on the left no longer frame the pathway with the same assurance, but emerge as partial branches into the composition. Given Stillfried's attention to the arrangement of a scene, such alterations to the pictorial frame were bound to upset the delicate balance and unity of the original work.

In the process of cropping his topographical photographs, Stillfried not only removed the caption, but all suggestion of local specificity inherent in the original portfolio. From a particular location on a familiar route, the view became a generic mountain scene of Japan. Through this process, Stillfried adapted to the new market conditions. Like all successful commercial photographers, he recognised his principal clientele and adapted his merchandise to cater to their specific requirements. By removing the titles and those early negatives depicting signs of Japanese modernisation, Stillfried transformed his topographical portfolio into a generalised, pre-industrial suite of photographs designed to attract the lucrative globetrotter audience. This systematic process indicates a strategic shift in his practice that reflects the changing local and international scene, not only of Stillfried's enterprise, but of the entire Yokohama photography industry.

Notes

This paper is an abridged version of chapter three from my dissertation "With Argus Eyes: The Early Life and Work of Baron Raimund von Stillfried-Ratenicz (1839-1911)." I wish to thank Roger Benjamin and Charles Green for their comments on an earlier draft of this paper, Ellen Conant, Hans Schreiber, and Clark Worswick for their research suggestions, and numerous institutions and private collectors for permission to reproduce works for this article. I must also acknowledge the Stillfried family, in particular Dr. Bernhard Stillfried, for its continued support of my work and permission to inspect the family archive in April 2001. Finally, my sincere gratitude to the Sainsbury Institute for the Study of Japanese Arts and Cultures for the opportunity to present my work at the conference and the various observations proffered by fellow delegates and audience members. Unless otherwise indicated, translations are mine.

1 For a thorough survey of source material regarding Stillfried's career in Japan and further afield, see Luke Gartlan, 'A Chronology of Baron Raimund von Stillfried-Ratenicz (1839–1911),' in John Clark, *Japanese Exchanges in Art, 1850s–1930s, with Britain, Continental Europe, and the USA* (Sydney: Power Publications, 2001), pp. 121–188.

2 Stillfried made this claim to H.L.T. Haakman during his visit to Amsterdam in October 1877. *Photographic News* 21, no. 1000 (2 Nov. 1877), p. 522.

3 The few scholars to mention Stillfried's outdoor practice have either denied or dismissed such work: 'It is not known whether Stillfried himself ventured outside his studio to photograph landscapes – his style seems to be best suited to studio work.' In Ellen Handy, 'Tradition, Novelty, and Invention: Portrait and Landscape Photography in Japan, 1860s–1880s' in Melissa Banta and Susan Taylor, eds., *A Timely Encounter: Nineteenth-Century Photographs in Japan* (Cambridge, Mass.: Peabody Museum Press, 1988), p. 62. In the opinion of the British photo-historian Terry Bennett: 'While I find Stillfried's landscape work uninspiring, his portrait work is undoubtedly of very high quality; and it is this aspect of his work for which he is deservedly remembered.' See Terry Bennett, 'Early Photographic Images of Japan', *The Photo Historian: Journal of the Historical Group of the Royal Photographic Society* 112, June 1996, p. 18.

4 Throughout this paper I adhere to Stillfried's own spelling for the place names depicted in his photographs, however eccentric or altered in modern usage. In many cases, these spellings reflect the transliteration of Japanese according to German phonetics (for instance 'Yokohama' was often spelled 'Jokohama').

5 Among numerous accounts to present an Arcadian view of Japan, see Eliza Ruhamah Scidmore, *Westward to the Far East: A Guide to the Principal Cities of China and Japan* (The Canadian

Pacific Railway Co., 1891), pp. 5-6.

6 Numerous foreign commentators bemoaned the country's rapid modernisation, the most acerbic criticisms being reserved for the adoption of foreign dress: '[The Japanese] are beginning now to cast off their own picturesque and becoming garments, and to adopt the European style of dress in its place; and in Yedo and Yokohama, yakonins are to be met in every street attired in most villainously-cut coats and trousers; they have also a weakness for jack-boots; and their whole get-up is strongly suggestive of scarecrows.' R. Mountenay Jephson and Edward Pennell Elmhirst, *Our Life in Japan* (London: Chapman & Hall, 1869), p. 181.

7 According to one thesis, Stillfried's Japanese photographs present a culture unaffected by modernisation: 'Japan's state of transition was clear to foreign visitors, some of whom wanted to record, or acquire records of, social customs in Japan, a kind of salvage documentation, before the country was irrevocably changed.' Eleanor M. Hight, 'The Many Lives of Beato's 'Beauties',' in Eleanor M. Hight and Gary D. Sampson, eds., *Colonialist Photography: Imag(in)ing Race and Place* (London and New York: Routledge, 2002), p. 151. The occasional depiction of Japanese modernisation in his early work, however, raises a fundamental query regarding this presumed 'salvage' project and the customer base for such work.

8 Rather than the publication of a certain year, *Views and Costumes of Japan* was the generic title for Stillfried's Yokohama albums throughout the 1870s.

9 According to the library catalogue: 'Stillfried and Company. Views & Costumes of Japan. [presented to Rev. S. R. Brown by the Union Church of Yokohama] Yokohama [1862] 2 v. of 100 mounted photo. (10 col.). 35 x 46 cm.' *Library Catalogue of the Metropolitan Museum of Art, New York*, 2nd. ed., vol. 40 (Boston, MA.: G. K. Hall & Co., 1980), p. 279. On the frontispiece mounting, the album is dated '1862' in black handwritten crayon, however this is clearly erroneous.

10 Of the 90 landscape prints, only prints 18, 40, 67, 68, and 100 are of smaller dimensions, ranging between 18.2 x 23.0 cm and 19.3 x 24.1 cm. Unlike the other prints in the albums, these works are untitled.

11 A survey of the auction records also testifies to the rarity of these albums. A group of 16 hand-tinted portrait prints, accompanied by a No. 61 title

page, sold at Sotheby's Belgravia, *Photographic Images and Related Material* (London: 21 March 1980), items 98 and 99.

12 On Stillfried's change of address to No. 59, Main Street, see The *'Japan Daily Herald' Annual Directory and Hong List, for Yokohama, Yedo, Kobe, Osaka, Hakodate, Nagasaki & Niigata, for the year 1873* (Yokohama: 'Japan Daily Herald and Shipping List', 1873) and *The China Directory*, 1873 (Hong Kong: A Shortrede & Co.) p. 14S.

13 A sample of the Bibliothèque Nationale photographs appeared in Bernard Marbot, *Objectif Cipango: Photographies anciennes du Japon*, exh. cat. (Paris: Bibliothèque Nationale, 1990); many of the photographs are either unattributed or falsely attributed to Felice Beato (an indication of the confusion surrounding Stillfried's early work). I am indebted to Clark Worswick for bringing my attention to the New York private album, and the collector for permission to study the album. Finally, the Bern collector came to my notice through the European dealer/collector grapevine, and I am most thankful for his hospitality during my visit to Switzerland in August 2001.

14 In conjunction with the Brown album, *The Far East* review cited in this article (see note 23) furnishes the primary evidence that these black and white captioned photographs date from mid-1871. In addition, the first photograph in the New York album, bearing the black and white title *Yokohama-bund*, includes a handwritten caption on the mounting, presumably by the original owner: 'After the Typhoon. August 22nd 1871.' According to the *Japan Mail Summary*, a typhoon struck Yokohama on August 24, 1871, causing damage along the Bund. *Japan Mail: A Fortnightly Summary*, 11 Sep. 1871.

15 A few photographs bearing a black and white caption depict sites in Kyoto and Nagasaki, suggesting that Stillfried continued the procedure in a few cases. There are four such examples in the Brown album: *Kioto-castle*, print 69; *Kioto*, print 71; *Choin*, print 74 and *Nagasaki*, print 90.

16 According to a contemporary article 'Myanoshita': 'This is a favourite spot among the Hakone range of mountains, to which many of our townspeople resort for pleasure or for health, during all seasons except the winter. It has a most excellent tea-house, where visitors are made as comfortable as they can be, in this land of the Rising Sun, at a hotel. Attached to the house are hot water sulphur baths, the water bubbling up from a spring at the back of

the house, and led into it by means of bamboo pipes.' *The Far East* 2, no. 14 (16 Dec. 1871), p. 168. A companion photograph in the Bibliothèque Nationale, Paris, depicts the bamboo piping: *Mianoshta*, E016883.

17 These works form a three-part panorama of Tokyo, previously attributed to Felice Beato and reproduced in Claudia Gabriele Philipp, Dietmar Siegert and Rainer Wick (eds.), *Felice Beato in Japan: Photographien zum Ende der Feudalzeit, 1863-1873* (Heidelberg: Edition Braus, 1991), pp. 106-107.

18 'Baron Stillfried' departed from Yokohama aboard the *Costa Rica* on May 7, 1872 (*Japan Weekly Mail* III, no. 19, 11 May 1872, p. 280) and arrived in Nagasaki aboard the *Oregonian* on May 29 (*The Nagasaki Express* III, no. 125, 1 June 1872, p. 498). This three-week interim provided sufficient opportunity to disembark at Kobe and visit Osaka and Kyoto. 'Baron Stilfried and servant' left Nagasaki aboard the *Oregonian* on June 9 (*The Nagasaki Express* III, no. 127, 15 June 1872, p. 506) and arrived back in Yokohama on the same vessel on 14 June (*Japan Weekly Mail* III, no. 24, 15 June 1872, p. 369).

19 One foreigner to visit the exhibition noted: 'The Japanese government have gotten up an exposition at Kioto and thrown it open to foreigners for fifty days of their own accord. Of course, every one in Japan who can get away takes a run up to this most sacred of Japanese cities. . . .' Christine Wallace Laidlaw, ed., *Charles Appleton Longfellow: Twenty Months in Japan, 1871-1873* (Cambridge, Mass.: Friends of the Longfellow House, 1998), p. 134.

20 Laidlaw, p. 135.

21 'Baron Stillfried' departed Yokohama for Hakodate aboard the *Relief* on October 4, 1872 (*Japan Weekly Mail* III, no. 40, 5 Oct. 1872, p. 653). He left Hakodate on the return voyage on November 28 and arrived in Yokohama on December 3 (*Japan Weekly Mail* III, no. 49, 7 Dec. 1872, p. 791).

22 The Scottish/Australian John Reddie Black was well qualified to assess Stillfried's photographic talent. Although primarily known for his journalistic exploits, there is mounting evidence of his role in early Yokohama photography. His most evident contribution was as the editor of *The Far East*, a magazine published in Yokohama (1870–1875) and thereafter in Shanghai (1876–1878), illustrated with several hundred original photographs. See Stephen White, 'The Far East: A Magazine on the Orient for European Eyes', *Image* 34, nos.1–2, 1991, pp. 39–47. Black was the principal mentor of the young Austrian photographer Michael Moser (1853–1912), offering him a position as photographer for *The Far East*.

23 'Photographic Views by Messrs. Stillfried & Co.', *The Far East* 2, no. 10 (16 Oct. 1871), p. 120.

24 A. Martinez, *Wiener Ateliers: Biographisch-kritische Skizzen* (Wien: Plant & Co., 1891), p. 30; Alfons Stillfried, *Die Stillfriede: Drei Jahrhunderte aus dem Lebensroman einer österreichischen Familie* (Wien: Europaischer Verlag, 1956), pp. 159–160.

25 Ernst Kossak, ed., *Professor Eduard Hildebrandt's Reise um die Erde*, 5. Auflage (Berlin: O. Janke, 1876).

26 Stillfried's resignation from the Austrian army was announced in the *Militär-Zeitung* XVI, no. 6 (21 Jan. 1863), p. 48.

27 'Desima. Textor & Co., E. A. Boeddurghaus, F. Dillmer, R. Stillfried godown keeper.' *The Chronicle and Directory for China, Japan and the Philippines for 1865* (Hong Kong: 'Daily Press', 1865), p. 244.

28 Stillfried Family Archive, Vienna. On Parker, see Sebastian Dobson and Terry Bennett, *The Theme and Spirit of Anglo-Japanese Relations* (London: The Japan Society, 1998), pp. 7–8.

29 Stillfried correspondence to the Imperial Foreign Ministry (*k. k. Ministerium des Äußern*), 22 Aug. 1868, *Haus-, Hof- und Staatsarchiv*, Vienna, Admin. Reg. F.34, S.R., appendix 1, part 1, no. 80, cited in Gert Rosenberg, *Wilhelm Burger: Ein Welt- und Forschungsreisender mit der Kamera 1844-1920* (Wien-München: Christian Brandstätter, 1984), p. 25.

30 Sixteen years later in a speech to the Anthropological Society in Vienna, Stillfried claimed that he was present in Nagasaki in 1868. Baron Stillfried, 'Japan und seine Bewohner', *Mitteilungen der Anthropologischen Gesellschaft in Wien, Suppl.: Verhandlungen* 14, 1884, p. 38.

31 'Yeddo Legations. North German Confederation. *Chargé d'Affaires and Consul General*—Von Brandt, *1st interpreter* – Kempermann, F.P., *Interpreter* – Berlin, Dr., *Assistant* – Hillfried, Baron [sic]'. *Japan Herald Directory and Hong List for Yokohama, 1st March 1870* (Yokohama: Japan Herald, 1870), 2. Max von Brandt served as Prussian representative in Japan 1862–1874, and in Beijing 1874–1893. M. von Brandt, *Dreiunddreissig Jahre in Ost-Asien: Erinnerungen eines deutschen Diplomaten*, 3 vols. (Leipzig: Georg Wigand, 1901).

32 Rosenberg, pp. 25–26.

33 Stillfried Reports, Aug. 22, 1868 – Sep. 14, 1869, *Haus-, Hof- und Staatsarchiv*, Administrative Registratur, S.R., 1868–1872, 69/5, cited in Peter Pantzer, *Japan und Österreich-Ungarn: die diplomatischen, wirtschaftlichen und kulturellen Beziehungen von ihrer Aufnahme bis zum Ersten Weltkrieg* (Wien: Institut für Japanologie, Universität Wien, 1973), pp. 211–212.

34 '. . . in Berücksichtigung hervorragender Leistungen aus Anlass Unserer Mission nach Ost-Asien und Südamerika. . . .' Certificate of the Franz Joseph Order, Stillfried Family Archive, Vienna.

35 On Burger and Moser in Japan, see Rosenberg (as in note 29), chap. two.

36 'Von der Ostasiatischen Expedition', *Mittheilungen des k. k. Österreichischen Museums für Kunst und Industrie* 5, no. 52 (15 Jan. 1869), pp. 81–82.

37 A. Th., 'Freiherr von Stillfried-Ratenicz und sein japanisches Theehaus,' *Allgemeine illustrirte Weltausstellungs-Zeitung* 5, nos. 9–10 (9 Nov. 1873), p. 103: 'Der eintönigen Thätigkeit in dem norddeutschen Consulat müde, wurde Stillfried dann Kaufmann in Jeddo und beschäftigte sich mit dem Import von Utensilien zur Photographie, welche damals, da in Japan das Photographiren grossen Aufschwung nahm, ein gutes Absatzgebiet fanden.' Although the exact date of his resignation from the diplomatic post is not known, Stillfried presumably opened the Tokyo shop in the latter half of 1870.

38 *The Hiogo News*, 9 Aug. 1871, cited in Harold S. Williams Collection, National Library of Australia, Canberra, HSW Box 15.

39 This problem is evident, for example, in Bernhard Marbot's otherwise useful catalogue *Objectif Cipango* (see note 13). The reproductions of catalogue entries 12, 31, 36, 37, 39, 42, 45, 46, 47, 49, 51, 55, 60, 63, and 70 are either unattributed or falsely attributed to Felice Beato. All of these photographs can now be firmly credited to Von Stillfried.

40 The paper watermark 'B.F.K. Rives 1865' is discernible on the 74th print entitled *Choin* (fig. 2) in the Brown album. This mark refers to the prominent albumen paper manufacturer Blanchet Frères et Kléber Co. in Rives, France, a firm renowned for the quality of its merchandise. In most cases, its paper was sent to Dresden factories to be coated with albumen before packaging and distribution around the world. James M. Reilly, *The Albumen & Salted Paper Book: The History and Practice of Photographic Printing, 1840–1895* (Rochester, NY: Light Impressions, 1980), pp. 28–34.

41 *The 'Japan Gazette' Hong List and Directory for 1872* (Yokohama: 'Japan Gazette', January 1872), p. 23. William Willmann was another little-known Central European photographer active in early Meiji Japan. Neither his background nor his activities on leaving Japan are currently documented. He departed Shanghai for Yokohama on March 29, 1868 (*North China Herald* II, no. 50, 1 April 1868, p. 156). Soon after settling in Japan, he became a partner in the merchant firm *Rothmund, William & Co.* and thereafter established the general store Willmann & Co. at No. 61, Main Street (*The Japan Mail: A Fortnightly Summary* II, no. 2, 22 February 1871, p. 59). As a photographer, he remained Stillfried's principal assistant from 1871 to 1875, and for a brief period in 1873–74, took over the studio under the company name 'W. Willmann's Photographic Establishment'.

42 The principal biographical source on Brown remains *William Elliot Griffis, A Maker of the New Orient, Samuel Robbins Brown, Pioneer Educator in China, America, and Japan. The Story of his Life and Work* (New York: Fleming H. Revell Company, 1902) hereafter cited as *A Maker of the New Orient*.

43 On the overseas exchange of Japanese students to Munson, Massachusetts, see *A Maker of the New Orient*, p. 206. Samuel R. Brown's textbook appeared under the title *Colloquial Japanese, or Conversational sentences and dialogues in English and Japanese, together with an English/Japanese index to serve as a vocabulary, and an introduction on the grammatical structure of the language* (Shanghai: Presbyterian Mission Press, 1863).

44 *A Maker of the New Orient*, p. 178.

45 On May 3, 1860, the American merchant Francis Hall noted in his diary spending 'the forenoon at Simmons's photography.' As Fred Notehelfer notes, Simmons returned the camera to S.R. Brown on his resignation from the mission later that year, whereupon Brown's daughter became an amateur practitioner. Notehelfer does not mention her father's participation in such endeavours, however they would seem likely in view of Griffis's comments. F.G. Notehelfer, ed., *Japan through American Eyes: The Journal of Francis Hall, Kanagawa and Yokohama, 1859–1866* (Princeton, N.J.: Princeton University Press, 1992), pp. 161–62.

46 *A Maker of the New Orient*, p. 179.

47 *A Maker of the New Orient*, p. 179, pp. 239–240.

48 Among the most poignant testaments to such

interaction was the friendship of Shimooka Renjō and the Yokohama merchant and amateur photographer Samuel Cocking, Senior. In his correspondence to a British photography journal, Cocking wrote: 'Photography was first introduced here about fifteen years since, when an old Japanese friend of the writer's learnt the art as it then existed, and practised the collodion process.' S. Cocking, 'Notes from Japan,' *The British Journal of Photography* XXIV, no. 884 (13 April 1877), p. 173.

49 *A Maker of the New Orient*, p. 237.

50 Baron Raimund Stillfried, 'Japan auf der Weltausstellung. II', *Allgemeine Illustrirte Weltausstellungs-Zeitung* 5, nos. 1–2 (14 Sep. 1873), p. 8: 'Mit der wiederkehrenden Ruhe und Ordnung beginnt nun die eigentliche Reformation. Die Emigration wird freigegeben, Schaaren von Japanern wandern nach Europa und Amerika, um dort zu lernen und dann als Jünger der Wissenschaften nach ihrer Heimat zurückzukehren, Hiogo-Osaka, Niegata und Jeddo werden dem fremden Handel geöffnet, Eisenbahnen und Telegraphen gebaut, Schiffswerften, Fabriken und Arsenale angelegt, das Steuer- und Münzwesen geregelt, Armee und Flotte reorganisirt, Schulen und Anstalten mit fremden Lehrkräften gegründet, Ausstellungen für Landwirthschaft, Kunst und Industrie abgehalten u. s. w.'

51 There was indeed a large contingent of Royal Marines stationed in Yokohama during the first half of the 1870s, several of whom also pursued an amateur photographic interest in their leisure hours, including Frederick William Sutton and John Hartley Sandwith.

52 For example, the fourth print in the album, *Katasse-Temple*, includes the caption 'Temple de Katori – 10 kilometres de Yokohama' and the tenth print, the pencil inscription 'Auberge de la belle Espagnole – sur la route de Yeddo.'

53 *Across the Continent and Around the World: Disturnell's Railroad and Steamship Guide: Giving the Great Lines of Travel Around the World, by Land and Water; also containing a list of all the railroads in the United States and Canada, and other useful information relating to Steamship Lines, Telegraph Lines, etc.* (Philadelphia: W.B. Zieber, 1872), p. 113.

54 In addition to Disturnell's, other early guides directed to the global tourist include *The Picturesque Tourist: A Handy Guide Round the World, for the use of all Travellers between Europe, America,* *Australia, New Zealand, India, China, and Japan*, 2nd ed. (London: Hamilton Adams & Co., 1877) and Thomas Cook, *Letters from the Sea and from Foreign Lands, descriptive of a tour around the World, by Thomas Cook* (London: Thomas Cook & Son, n.d.).

55 The first regional guidebooks included *Guide Book of Yedo: The Tokio Guide, by a resident* (Yokohama: F. R. Wetmore, 1874) and *The Yokohama Guide* (Yokohama: F.R. Wetmore & Co., 1874). These booklets were later superceded by W.E.L. Keeling, *Tourists' Guide to Yokohama, Tokio, Hakone, Fujiyama, Kamakura, Yokoska, Kanozan, Narita, Nikko, Kioto, Osaka, etc., etc.* (Tokio: Sargent, Farsari, & Co., 1880) and the first comprehensive guide, Ernest Mason Satow and A.G.S. Hawes, *A Handbook for Travellers in Central and Northern Japan* (Yokohama: Kelly & Co., No.28, Main Street, 1881).

56 According to the *Oxford English Dictionary*, the term 'globetrotter' first appeared in E.K. Laird's *The Rambles of a Globe Trotter in Australasia, Japan, China, Java, India and Cashmere*, 2 vols. (London: Chapman & Hall, 1875). In fact, an article in the Yokohama press indicates that the term was already in usage in the port: 'Globe trotters,' *The Japan Mail*, 22 Aug. 1873, pp. 540–541.

57 For the Japan travel accounts of these two early Stillfried customers, see Laidlaw (as in note 19) and Josef Doblhoff, *Tagebuchblätter von einer Reise nach Ostasien, 1873–1874*, 3 vols. (Wien: Kohler, 1874–1875).

58 *Hong Kong Daily Press*, no. 4743 (23 Jan. 1873), p. 1.

59 *Photographisches Correspondenz* 10, no. 107 (1873), p. 85; *Photographisches Archiv* XIV, no. 275 (20–8–1873), p. 139.

60 'Die Ansichten von Japan, von Baron Raimund Stillfried,' *Allgemeine illustrirte Weltausstellungs-Zeitung* 5, no. 4 (28 Sept. 1873), p. 40: 'Es gereicht uns zum besonderen Vergnügen unseren Lesern mittheilen zu können, dass unser geschätzer Mitarbeiter, Herr Raimund Baron Stillfried, weleher [sic] bekanntlich ein fotografisches Atelier in Japan besitzt, für seine in der Collectiv-Ausstellung des österreichischen Fotografen-Vereins Gruppe XII ausgestellten, Ansichten aus Japan' mit der Fortschritts-Medaille ausgezeichnet wurde.

Dem Laien schon, vorausgesetzt, dass er mit Kunstsinn und Geschmack begabt ist, wird es leicht werden, die Vorzüge, welche die Bilder Stillfried's

auszeichnen, sofort zu erkennen.

Der Fachmann aber staunt über die grosse technische Vollendung der erwähnten Bilder, welche um so anerkennenswerther ist, wenn man die bedeutenden Schwierigkeiten bedenkt, unter welchen Stillfried gearbeitet haben mag.

Die geniale künstlerische Auffassung, die Weichheit der Nuttaltöne [sic], die Zartheit in den Details selbst der tiefsten Schattenparthien, die kräftigen und doch nicht grellen Uebergänge von Licht und Schatten, die Reinheit der Himmel sind Eigenschaften, die bis jetzt unübertroffen dastehen.'

61 I am grateful to Hans Schreiber, Vienna, for bringing my attention to this collection preserved in the Rollettmuseum der Stadtgemeinde Baden, Austria.

62 Of the extant albums currently known to possess the No. 59, Main Street studio frontispiece, only the large album in the Picture Collection, State Library of Victoria, Melbourne, Australia, includes a completed index page. A second album in the Edoardo Chiossone Museum of Oriental Art, Genoa, Italy, contains an identical index page, however it remains blank. I would like to express my thanks to Ellen P. Conant for informing me of the Chiossone album.

PACKAGED TOURS

Photo Albums and Their Implications
for the Study of Early Japanese Photography

Allen Hockley

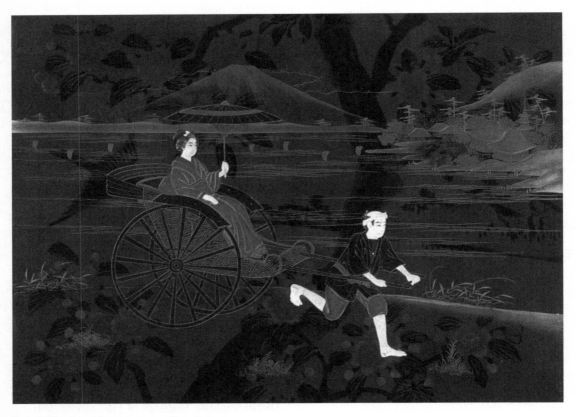

Detail, Fig. 11 Album cover, studio unknown.

Introduction

Archival recovery is a prerequisite of any emerging field, and those of us studying early Japanese photography recognise the need to recommit to this enterprise on a regular basis in order to support our own research and further the field as a whole. But there are protocols inherent to archival practice that can be potentially misleading. Many of the typologies we rely on to render the vast corpus and wide variety of images more manageable are constructs we create and impose on the archive. When we shift from archival tasks to interpretive analysis, the organisational paradigms that served so well for the former skew the latter in directions that do not necessarily reflect the essential characteristics of the art.

Nineteenth-century Japanese photography was, for the most part, a commercial enterprise in which an entrepreneurial outlook and good

business sense were as necessary for success as a gifted eye or technical facility with the medium. The viability of a studio was especially contingent on the photographer's capacity to assess the desires, needs, and expectations of his clientele who, for the most part, were foreign tourists and residents of Japan's treaty ports. For art produced in such circumstances, authorship and attribution, subjects of considerable importance in archival study, become particularly problematic. Photographers certainly created the actual images, but as with any commercial product, the potential sale and, by extension, the intended consumer projected a powerful presence during production. Accordingly, we must resist the tendency, so thoroughly conditioned in both archival and art historical practice, to privilege the artists. Agency for the imagery ought to be posited with its consumers. Otherwise, interpretive studies built solely on a foundation of authorship and attribution will ultimately be incomplete, if not altogether inaccurate.

Of the many products offered by commercial photography studios, photo albums, especially those of the 1880s and '90s, are ideally suited to probe the issues raised here. All commercially made photographs afford potential insights into the market for which they were produced, but photo albums facilitate analytical perspectives that single images cannot. Typical albums contained from 25 to 100 highly varied images. The histories of specific subjects, themes and genres – categories frequently used to organise the archive – intersect in photo albums and provide the opportunity to explore their interrelationships not only more fully than otherwise possible, but also in a manner more in keeping with the way they would have been understood at the time.

As the premier products offered by commercial studios, albums figured prominently in advertisements photographers placed in a variety of publications. These ads convey the producers' perspective on the market but they are also important indicators of changes in the tastes and preferences of their clientele. Album formats – meaning the way they were bound, the materials from which they were constructed, and their use of text – also evolved along a trajectory intimately linked to the market for which they were designed. In other words, albums facilitate a documentable history – not of artists or studios – but of commercial products.

The images in most photo albums of the 1880s and '90s were selected and arranged by westerners who patronised the commercial studios. When viewed from this perspective, albums become finite contexts unto themselves, defined by the experiences and perceptions of their buyers. They invite us to seek out the sensibilities and predilections that governed the selection process. They force us to question the rationale underlying the sequencing of images. The ability of albums to summarize the experiences and perceptions of foreign travellers and, more specifically, their capacity to narrate travel itself, elicit analytical perspectives that compel us to search for the meaning of photographs among consumers as opposed to their producers. In short, photo albums invite us to explore the implications of a consumer-driven history of early Japanese photography, and in doing so, question the archival paradigms currently informing this emerging field of study.

Distinguishing features of late-nineteenth-century photo albums

Defining the essential characteristics of photo albums produced in the 1880s and '90s necessitates two lines of enquiry. Some features of later albums can be traced to precedents established by photographers working in the 1860s, while others are the result of market conditions specific to the last decades of the nineteenth century.

Evidence suggests that Felice Beato (1834–1908) was the first photographer to recognise the commercial potential of albums.

In the process, he developed the prototypes which later photographers adjusted to suit their clientele.[1] Advertisements placed by Beato's predecessors, William Saunders (active early 1860s) (fig. 1) and Charles Parker (active ca. 1863–1868) (fig. 2), in the September 18, 1862 and September 12, 1863 issues of the *Japan Herald* respectively, promote individual photographs and portrait services.[2] Beato's earliest known advertisement, a photograph of his price list datable to 1864 or 1865, mentions individual photographs of various sizes, *cartes de visite*, and portraits in two sizes, but not albums.[3] The bottom half of the ad, however, offers albums of sketches, watercolours and oil paintings by Charles Wirgman (1832–1891), Beato's business partner.[4] If this advertisement is any indication, Beato had not yet begun selling photographic albums, but the fact that Wirgman's sketches and paintings were available in album format, suggests a

Fig. 1 Advertisement, William Saunders, *Japan Herald*, 1862.

precedent in the making. Beato's first album, *Photographic Views of Japan with Historical and Descriptive Notes, Compiled from Authentic Sources, and Personal Observation During a Residence of Several Years*, published in 1868, seems to represent the point when this potential was finally realised. His

Fig. 2 Advertisement, Charles Parker, *Japan Herald*, 1863.

subsequent success with albums prompted Wirgman to offer a backhanded compliment in the form of a humorous illustration in the June 1869 issue of *Japan Punch*.[5] Entitled 'Count Collodion's [i.e. Beato] Album Thermometer', it satirizes Beato's fixation upon photo albums.

An advertisement Beato placed in the February 2, 1870 issue of the *Japan Weekly Mail* (fig. 3) suggests that albums, indeed, became the mainstay of his business.[6] In its entirety the ad reads as follows:

Signor F. Beato, Begs to announce to the Public of Yokohama and Travellers visiting the East generally that he has just completed a handsome collection of Albums of various sizes, containing views &c., of Japan, with descriptions of the Scenes, Manners and Customs of the people compiled after visiting the most

interesting localities in the country during six years residence. No. 17 on the Bund.[7]

In stark contrast to earlier examples, this advertisement does not mention individual photographs, although Beato continued to make them available to his customers. Instead, it focuses entirely on albums. Beato pitched the ad to his primary market, 'the public of Yokohama and travellers visiting the East'. He promoted specific features of his product line including a range of sizes and a variety of images, loosely grouped in two genres: scenes and manners or customs. Beato also mentioned that his albums include descriptions of the images. Wirgman authored these, in effect, narrating on behalf of the viewers the visual experience Beato provided through photographs. Note that the ad validates Beato's expertise with a reference to his 'six years residence'. Moreover, and most important, the albums were sold as 'completed'. In other words, Beato – the photographer – was entirely responsible for their content.

Beato dominated the early commercial photography business but competition increased substantially as several factors contributed to an exponential rise in the number of photographers plying their skills and products in the early 1870s.[8] With the voyage of the Colorado in January 1867, the Pacific Mail Steamship Company established regular service between San Francisco and Yokohama. Smaller steamers plying routes through the Inland Sea linked Japanese ports to Shanghai and Hong Kong.[9] Completion of the Suez Canal and the U.S. transcontinental railway in 1869 brought increasing numbers of westerners to Japan from Europe and America's populous east coast. By 1872 travel to Asia improved to the point where Thomas Cook began promoting round-the-world tours.[10]

The size of the foreign community and the number of visitors to Japan grew steadily from the time the treaty ports were first occupied in

1859, but the rate of growth increased dramatically after 1868 when the new Meiji administration embarked on an ambitious course of rapid modernisation. The desire for western expertise and the trade necessary to support modernisation required a relaxation of restrictions on foreign residents and visitors. Travel within Japan underwent significant changes as a result. A new rail line between Yokohama and Tokyo in 1872 – a product of modernisation – made Tokyo as familiar to western travellers as any city on Europe's grand tour. Local steamship routes between Yokohama and Nagasaki substantially increased the western presence in Kobe and vicinity. The Kyoto Exhibition of 1872 prompted plans for a Kobe-Osaka-Kyoto rail line, which opened a few years later. Travel outside Tokyo and the treaty ports required passports but this did little to dampen the enthusiasm of tourists. Local Japanese

Fig. 3 Advertisement, Felice Beato, *Japan Weekly*, 1870.

authorities in Yokohama could grant immediate permission to visit Hakone and its vicinity. Their counterparts in Kobe and Nagasaki could grant similar permission to visit Kyoto and the Ureshino and Takeno areas respectively. Travel to more remote destinations required approval from the Japan Foreign Office. Applications were made through the western consulates and needed justification on the grounds of ill health, botanical research, or scientific investigation. However, anecdotal evidence suggests that passports were relatively easy to acquire. Arthur Crowe, who could not recall

the grounds on which he acquired his passport, wrote in 1883:

> A specified route and time must be given, but ours includes the provinces of Kinai, Tokaido, Tosando, and Hokkaido, practically the whole of Japan, except Kiusiu, and is available for three months. Among the forbidden acts mentioned in the passport are the following: Travelling at night in a horse carriage without a lantern. Attending a fire on horseback. Driving quickly on a narrow road. Scribbling on temples, shrines, or walls. Lighting fires in woods or on hills or moors.[11]

By the mid-1870s, Nikkō, with its spectacular shrines and relative proximity to Tokyo (by *jinrikisha* (rickshaw) the trip could be made in two days) emerged as the most popular tourist destination. The Tōkaidō and, for the really adventurous, the Nakasendō, became the most popular overland routes.

New opportunities for travel within Japan spawned a need for authoritative guidebooks. The first of many, N.B. Dennys' *The Treaty Ports of China and Japan*, was published in 1867, prior to the opening of the country to tourists. It focuses primarily on Yokohama and Nagasaki, the most active of the treaty ports, whereas Hakodate receives little coverage (Niigata and Hyōgo were not yet opened to western settlement). Edo, soon to be renamed Tokyo, is discussed as a possible excursion from Yokohama. Dennys relied heavily on Kaempfer's 1727 *The History of Japan* and Alcock's 1863 *The Capital of the Tycoon*, not necessarily the most current information but adequate for the needs of pre-Meiji tourists.

Although a rather small volume, William Griffis's *The Tokio Guide*, published in 1874, set the standard for later guidebooks. Much of what he wrote was based on personal experience, making the information he provided current and far more detailed than

that provided by Dennys. Griffis also initiated a practice of recommending knowledgeable books travellers could consult as references. Mitford's *Tales of Old Japan* and Humbert's *Japan and the Japanese Illustrated* headed his list.

Recognising the expanded opportunities for travel, N. McLeod's 1879 *Album and Guide Book of Japan* covers more sites that its predecessors, but Satow and Hawes' *A*

Fig. 4 Advertisement, Kusakabe Kimbei, Douglas Sladen's *Club Hotel Guide*, 1892.

Handbook for Travellers in Central and Northern, the first edition of which was published in the early 1880s, superseded all earlier guides. Its 500-plus pages set the standard in terms of coverage, accuracy and comprehensive advice to travellers. Reissued in several editions, it remained the guide of choice until Basil Hall Chamberlain and W.B. Mason published *A Handbook for Travellers in Japan* in 1889. W.E.L. Keeling's less detailed

but more portable 1885 *Tourists' Guide to Yokohama, Tokio, Hakone, Fujiyama, Kamakura, Yokoska Kanozna, Narita, Nikko, Kioto, Osaka, etc., etc.* provided an alternative to Satow and Hawes. It too went through several editions, eventually competing with Chamberlain and Mason's guide. But Keeling's guide, as well as Douglas Sladen's 1891 *Club Hotel Guide to Tokyo and Yokohama* were far more commercial in the sense that both

Fig. 5 Advertisement, Tamamura Kōzaburō, Douglas Sladen's *Club Hotel Guide*, 1892.

contained several pages of advertisements placed by a wide variety of tourist-oriented businesses, photography studios among them.[12] Farsari (1841–1898), a leading commercial photographer, published Keeling's guide and Sladen went so far as to advise tourists to begin their tours with a visit to a photography studio, 'for one can get no surer index of what is worth seeing in Japan than by looking through Farsari's cabinets of photographs,

which embrace a large portion of the Empire.'[13] Keeling and Sladen's guides were aimed primarily at globetrotters as opposed to the more serious minded travellers who were willing to venture far from the treaty ports, needing, therefore, more thorough advice provided by Satow and Hawes or Chamberlain and Mason.

By the 1890s, the tourist industry had grown to the point where several guidebooks authored by Japanese competed with those of Keeling and Sladen. Amenomori's *Imperial Hotel, Guide Book and Map of Tokio, Japan* and *The Grand Hotel, Limited Guide Book for Yokohama and Immediate Vicinity*, both published in 1892, were highly popular. Shizuki Takahisa's *An Illustrated Guide-book to the Famous Places of Japan*, also published in 1892 but with an inlaid lacquer cover and dozens of tipped in woodblock-print illustrations, represents a luxury product targeted at a rather exclusive class of tourist.

The ever-increasing availability of photographic equipment and the novelty of the medium attracted Japanese to the business as both practitioners and consumers. Building on the enthusiasm generated by early pioneers such as Shimooka Renjō (1823–1914) in Yokohama and Ueno Hikoma (1838–1904) in Nagasaki, several enterprising Japanese photographers started up successful studios in the treaty ports and major cities. Initially, their primary clientele was Japanese desiring portraits or *cartes de visite*, but the advent of global travel coupled with the policy changes enacted by the Meiji administration enabled several photographers, notably Usui Shūzaburō (active c. 1877–1894), Uchida Kuichi (1843–1875), Suzuki Shinichi (1835–1918), Kusakabe Kimbei (1841–1934) (fig. 4), and Tamamura Kōzaburō (1856–1916) (fig. 5), to compete successfully in the tourist market with studios run by Westerners.

Following the lead of Beato and his contemporaries, later commercial photographers continued to advertise in newspapers published

in the treaty ports, but guidebooks quickly became the preferred venue in the 1880s – an obvious choice, given the emerging strength of the tourist market.[14] Keeling's 1880 *Tourists' Guide*, for example, featured ten advertisements representing most of the major studios and several smaller operators. Sladen's 1892 *Club Hotel Guide* included lengthy ads for Farsari, Kimbei, and Tamamura, by then the dominant

Usui's ad in Keeling's *Tourists' Guide* mentions 'Views and Costumes of Japan', as do advertisements placed by Kimbei, Baron Stillfried, and Stillfried and Anderson. Kimbei also promoted his photographs as the 'Best Views and Costumes of Japan' in Sladen's 1892 *Club Hotel Guide*. As noted, Beato was likely responsible for introducing the views and costumes concept to Japan.[16] His 1870

Fig. 6 Felice Beato, *Yokohama*.

enterprises catering to tourists. As competition escalated among studios and with a rapidly expanding amateur practice, commercial photographers began advertising a wider range of products and services.[15] Nonetheless, albums retained their status as the studios' premier product. Later advertisements demonstrate the significance of Beato's prototypes, but they also reveal several new features designed to attract the tourist market.

advertisement makes this distinction and many of his albums include both genres with the views preceding the types. The large number of albums from the 1880s and '90s that use this arrangement suggest that Beato's precedent remained the preferred choice among customers of commercial studios well into the early 20th century.

But advertisements of studios operating in the 1880s and '90s also stress aspects of their

practice left unsaid in Beato's 1870 ad. Among the ten photographers featured in W.E.L. Keeling's 1880 *Tourists' Guide*, Usui and Suzuki's advertisements include, in highlighted typeface, 'albums made and filled to order' and 'albums made to order'. Tamamura and Kimbei promoted large inventories of 1200 and 2000 images respectively in Sladen's 1892 *Club Hotel Guide*. Tamamura's ad states: 'I respectfully invite inspection' (fig. 5). Kimbei proclaimed, in upper case lettering and bold typeface: 'Inspection is invited' (fig. 4). We can be reasonably certain that Beato provided a similar service to his preferred clientele, but it was not promoted in his 1870 advertisement. Changes in the tourist industry expanded the range of activities available to travellers, forcing commercial photographers to offer tourists the opportunity to select personally photographs representative of their experiences in Japan. In short, choice became the operative word for later studios – their advertisements stress this point precisely.

The extensive captions Wirgman authored for Beato's albums also fell out of fashion as the range of opportunities for tourists increased in the 1870s. Wirgman's descriptions imposed control over the photographs with narratives that made it difficult to view them in a manner other than that which he stipulated. This practice ran contrary to the efforts of later studios to promote personalised albums. Their images were sometimes titled, often in grossly misspelled English, but even this became increasingly uncommon over time.

Whereas Beato's albums were typically cloth or leather bound along the left edge and had, therefore, the appearance of a Western-style book, later albums utilized elaborate covers of brocade or inlaid lacquer. Kimbei's 1892 advertisement in Sladen's *Club Hotel Guide*, for example, promotes 'Albums in Lacquered Board or Cloth Cover'. Studios offered a wide range of both graphic and pictorial designs with some representing subjects available in photographs.[17] Lacquer-covered albums,

moreover, were often bound orihon style, requiring viewers to open them left to right in the Japanese manner. In other words, the physical qualities of later albums and the materials from which they were made conveyed Japanese sensibilities that ultimately enhanced the impact of the photographs they contained.

The distinguishing features of later albums noted here provide access to the preferences and predilections of their consumers. Since most albums were purchased by westerners enjoying the new opportunities Japan's burgeoning tourist industry had to offer, they also embody the sensibilities of travel in Japan during the 1880s and '90s. Guidebooks and travel accounts written at the time provide an additional means to understand how photo albums functioned in this milieu.

Album covers

The great majority of Beato's albums begin with an image of Yokohama, and more often than not, one featuring the section of the port inhabited by westerners (fig. 6). As the most important of the five treaty ports owing to its proximity to Edo (renamed Tokyo in 1868), Yokohama's relevance is easily appreciated. It was the primary point of entry to Japan for most westerners travelling in the Far East.[18] And because the 1854 Treaty of Kanagawa, which established the treaty ports, confined foreigners to relatively small areas in their immediate vicinity (ten *ri* or about 25 miles in the case of Yokohama), day-to-day life for the permanent residents of Yokohama centered on the ex-patriot community. Photographs of Yokohama, therefore, define the experiences of both tourists and the permanent residents of the port. They were an obvious choice with which to begin a photo album.

The expanded range of experiences available to tourists in the 1880s and '90s resulted in a greater variety among the opening images of later albums. While the more adventurous travellers embarked for remote destinations in the interior, most stayed

relatively close to the treaty ports, primarily because round-the-world tours provided precious little time in some locales. Globetrotters continued to select images of Yokohama to open their albums, a choice driven not so much by their willingness to follow Beato's precedent, but rather by the desire to represent their experiences. Images of Yokohama's hotels, for example, replaced panoramas of the port but still conveyed similar meanings in the context of globetrotters' albums (fig. 7). More often than not, scenes of the treaty ports were omitted altogether. Many albums begin in Nikkō, Kyoto, or other destinations in the interior. For albums of this sort, lacquer covers represented the port of entry into Japan.

Designs on lacquer covers were extremely varied but as a group they exhibit some common features. Exoticism characterises most examples, particularly those depicting Buddhist deities, sages and *sennin* (fig. 8). Most cover designs feature easily recognisable, quintessentially Japanese images. Typically, landscape elements define the setting for a figural grouping (fig. 9). In the vast majority of examples Mount Fuji looms over the horizon, organising the pictorial space for the other motifs of the design. Its nearly symmetrical cone also functions as a powerful graphic element in the highly stylized visual mode employed for most cover designs.

Irrespective of the images they bear, all lacquer covers capture the essence of Japan by reducing the varied experiences it offered to a small number of emblematic motifs. But these motifs also frame the contents of albums in a

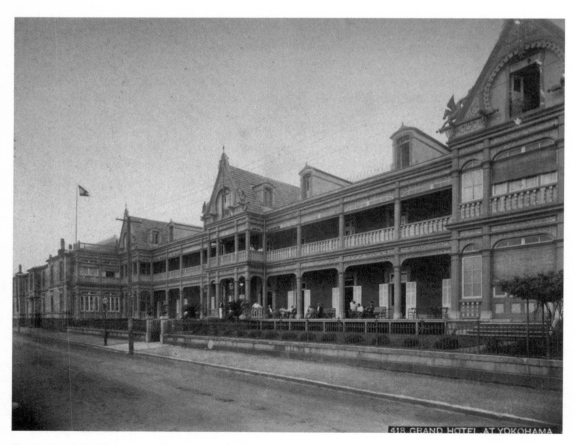

Fig. 7 Kusakabe Kimbei, *Grand Hotel at Yokohama*.

74

Fig. 8 Album cover, from the studio of Kusakabe Kimbei.

less obvious but highly important way. Virtually every travel narrative, from Engelbert Kaempfer's early eighteenth century tome to the lighthearted accounts of late-nineteenth-century tourists, includes commentaries on Mount Fuji. The earliest are primarily factual, focusing on its height and history of volcanic activity, but as Westerners came to appreciate the mountain, either through their own experience or by recognising its significance in Japanese culture, the amount of purely descriptive text increased substantially. Later writers, in particular, used Mount Fuji as a focus for the most poetically rendered passages of their narratives. Beato sensed the growing fascination for Mount Fuji among Westerners and made a number of photographs, which he included among the views of his pre-made albums. Knowing the popularity of Mount Fuji

and the iconic qualities of its image, later photographers continued to produce spectacular photographs of the peak. They appear with less frequency than in Beato's pre-made albums, however. And when compared with written descriptions in travel accounts, the profile of Mount Fuji in later albums seems considerably diminished. New itineraries, made possible by developments in the tourist industry during the 1870s, provide a plausible rationale for this shift in emphasis.

Westerners in Japan during the Tokugawa era generally had their first experience of Mount Fuji while travelling along the Tōkaidō. Several sections of this historically important highway provided spectacular views of the peak, but such views would have been encountered on route to their destination – the Tōkaidō was not travelled specifically to see

Fig. 9 Album cover, from the studio of Tamamura Kōzaburō.

Mount Fuji. By the 1880s, with a regular steamship service bringing tourists across the Pacific, most westerners encountered Mount Fuji for the first time as they approached Yokohama by sea. In the accounts of later travellers, Mount Fuji came to signify the beginning of their journeys in Japan. In effect it became the port of entry in travel narratives. When featured on the lacquer covers of albums, it served the same purpose, and in the process, made photographs of Yokohama redundant.

Travel narratives of the 1880s and '90s provide additional insights into the sensibilities informing the selection of album covers. As the conveyance of choice for most tourists, for example, westerners frequently went to great lengths describing every facet of their *jinrikisha* experiences. *Jinrikisha* became a reoccurring motif in travel accounts, linking the sites and scenes their authors encountered on route. Accordingly, *jinrikisha* images sometimes adorn the faux lacquer covers of travel books. Albert Tracy's 1892 *Rambles Through Japan Without a Guide* provides a particularly vivid example, understandably so, as Tracy travelled most of the Nakasendō in a '*kuruma*' (fig. 10). Based on much the same rationale, *jinrikisha* designs appear on the covers of many albums. As a mode of travel most tourists experienced directly, *jinrikisha* imagery on an album cover functioned as a

metaphor for the journey narrated by the images within (fig. 11).

But album covers also had much broader ranges of signification. Many depict *kago*, for example, a form of transport that rapidly disappeared with the advent of the *jinrikisha* (see fig. 9). In her 1891 travel account, appropriately titled *Jinrikisha Days in Japan* (which also included a *jinrikisha* on the cover) Eliza Scidmore wrote: 'As the *kago* [palanquin] gave way to the *jinrikisha*, the *jinrikisha* disappears before the steam engine'. Noting that railways had brought Kyoto and Tokyo to within 24 hours of each other, she continues: 'Before the iron horse had cleared all picturesqueness from the region the three of us made the *jinrikisha* journey down the Tokaido'.[19]

Fig. 11 Album cover, studio unknown.

If Scidmore and other travel writers of the 1880s and '90s are any indication, nostalgia for Japanese traditions rapidly disappearing as a result of modernisation was another factor motivating the selection of an album cover.

Album covers begin the journey through the images collected within but they also represented a summation of processes initiated prior to a traveller's journey. *Kago* and *jinrikisha*, for example, were common subjects for Beato (fig. 12). These images circulated widely as engravings in popular periodicals and books, such as the *Illustrated London News* and Aime Humbert's *Japan and the Japanese Illustrated* (fig. 13). For tourists, exposed to these publications before they journeyed to Japan, *jinrikisha* and *kago* had already acquired significant meaning long before they were considered as potential purchases for an album cover. In other words, album covers also marked the expectations travellers accumulated prior to their journey – expectations eventually fulfilled through personal experience and then commemorated with the purchase of an appropriate album cover.

Fig. 10 Cover design, from Albert Tracy, *Rambles Through Japan Without a Guide* (London: Sampson Low, Marston and Company, 1892).

Selection and sequencing of views

Beato generally organised the views in his pre-made albums by locale. Scenes of Yokohama were grouped together, as were those of Kamakura, Edo/Tokyo, Hakone and Nagasaki.

Sites such as Edo and Hakone, which entailed travel outside the treaty port limits, were sometimes ordered to convey the sense of movement to or from these destinations. When opportunities for travel expanded in the 1870s, photographers ventured along the popular routes making images of the sites and scenes that attracted the attention of tourists. As a result, the views' sections of later albums exhibit wider varieties of both images and sequencing.

The selection of specific views rested on several criteria, which varied from one consumer to the next. Generally tourists chose images within the realm of their lived experience. Travel to the actual place would have been the strongest motivation to purchase a photo but not absolutely necessary as some views were emblematic, much like the designs on lacquer covers. Travel restrictions on the residents of the treaty ports limited the access of early photographers to relatively few examples of certain types of sites, especially religious art and architecture, which were relatively scarce within the treaty port limits. Consequently, the Kamakura Daibutsu and Hachiman Temple acquired a relatively high profile in Beato's inventory and early albums. Articles in the *Illustrated London News* and early book-length travel accounts discussed these sites extensively, further enhancing their stature among westerners. Accordingly, views of these sites conceptualised and photographed in much the same way Beato had 20 years earlier, retained their emblematic value and appeared regularly in albums of the 1880s and '90s. Expanded opportunities for travel added other sacred sites to the repertoire of later photographers, the famous shrines at Nikkō being the prime example. As with Beato's images of Kamakura, photographs of Nikkō could represent in a generic sense, all shrines, all religious sites, or religious architecture in general.

Late-nineteenth-century albums also reflect individual differences among consumers. Travel accounts authored by Christian missionaries seldom had anything positive to say about Japanese religious institutions. Photographs of these subjects rarely appear in the albums they compiled. Similarly, Japan's extensive legacies of licensed prostitution were well known to westerners and frequently discussed in travel books, but missionaries and female tourists judiciously avoided images of the Yoshiwara, Japan's premier brothel district, and its courtesans. Photographs representing the interests and experiences of women who visited Japan sometimes diverged dramatically from those of men. Similarly, the images a sailor or merchant acquired were often different to those purchased by scholars. In short, late-nineteenth-century albums often betray the sensibilities their compilers brought to the task of selecting photographs. They reflect differences in class, occupation, gender, and perhaps even character.

While personal preferences resulted in highly varied selections of images, the sequencing of views in albums from the 1880s and '90s reveal far more regularity. Travel narratives suggest that guidebooks were the likely cause. Tourists were dependent on these publications. Citations are common and some authors quoted descriptions verbatim from the guides they used.[20] This dependence manifests in the sequencing of views in later albums. Many reveal remarkable consistencies with the itineraries described in guidebooks. Griffis' 1874 *Tokyo Guide* outlined 'skeleton tours' of one, two, three, and four days.[21] Each tour began in Yokohama and laid out a precise sequence of parks, temples, shrines, gardens, public buildings, and shopping districts of interest to Western tourists. Satow and Hawes adopted this practice, and extended it to the other treaty ports with skeleton tours originating in Kobe, Nagasaki, and in Hakodate. Travellers relied on these tours when they planned their itineraries. Evidently, they also carried their guidebooks into the photo studios when they selected and sequenced the images for their albums.

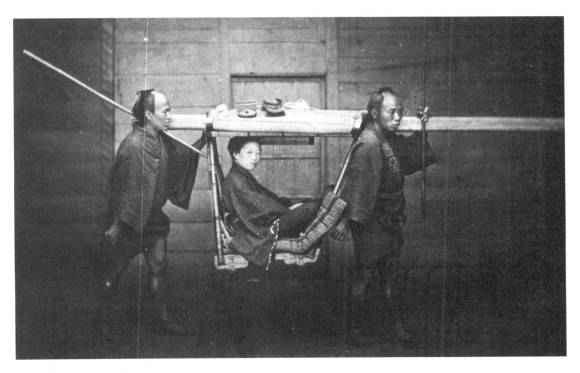

Fig. 12 Felice Beato, *Kago*.

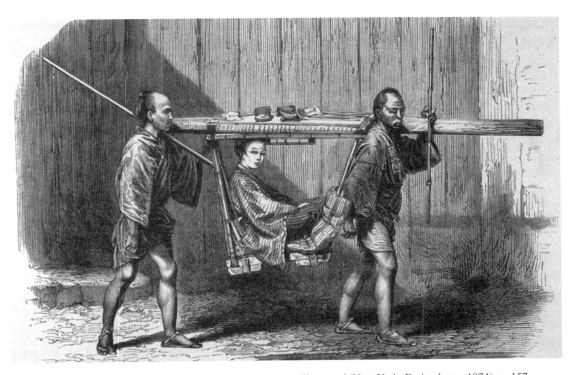

Fig. 13 *Kago*, from Aimé Humbert, *Japan and the Japanese Illustrated* (New York: D. Appleton, 1874), p. 157.

Views and costumes

With the views and costumes arrangement in use consistently from Beato's time to the early twentieth century, its significance in albums of the 1880s and '90s needs to be addressed. The genre defined as costumes, manners, or types included a wide variety of images. Street scenes, markets, shops, and other settings that presented Japanese going about their daily business constitute roughly half the images. Portraits posed in photographers' studios featuring costumes and accoutrements that distinguished different occupations, ages, and classes of Japanese fill out the genre. The sensibilities informing the selection of these images for albums were highly varied, complex, and well beyond the scope of this essay, but the relationship between views and costumes, specifically the implications of juxtaposing these two categories of images within the covers of an album, is pertinent to the issues raised thus far. The Tōkaidō provides a useful example.

A small section of this historically important highway lay within Yokohama's treaty limits. For the foreign residents of the port, the Tōkaidō was part of their lived experience. Beato frequently included Tōkaidō views in his albums for this reason. But written accounts from the time reveal that the Tōkaidō also had several extended associations. Humbert, a representative of the Swiss government stationed in Yokohama in the early 1860s, described many of these in his highly influential book *Japan and the Japanese Illustrated*. His discussion of the Tōkaidō appears in a chapter concerning the history of Japan from the Momoyama to the late Tokugawa eras.[22] The Tōkaidō enters the history when Humbert credited the highway for the success of Edo as an administrative and economic centre. From a narrative perspective, this observation enabled Humbert to draw Englebert Kaempfer into the discussion, noting the seventeenth-century Dutch physician's two trips along the thoroughfare. Kaempfer

travelled the Tōkaidō by *norimon*, an elaborate *kago*, as did Elgin and Alcock, two British diplomats stationed in Japan in the late 1850s and early 1860s. These diplomatic journeys provided Humbert with the opportunity to discuss modes of transport in use at the time, which he illustrated with several engravings based on Beato's photographs, including a mail runner, tattooed coolies, and, most notably, the photograph of a *kago* discussed above (see fig. 13). Humbert also narrated his own journey

Fig. 14 Felice Beato, *The Executioner*.

along the Tōkaidō from Yokohama to Edo, an experience many westerners had in the late-nineteenth century. This allowed him to segue into more recent history. As he passed the execution grounds on the outskirts of Shinagawa, he recalled the brutal murders of several westerners by samurai hostile to their presence in Japan.[23] Those charged with the crimes were put to death at the execution grounds with residents of Yokohama attending as witnesses. For Humbert, his readers, the treaty port residents, and those who acquired

Beato's albums, the Tōkaidō provided a culturally and historically rich experience easily accessible from Yokohama. In short, Tōkaidō photographs, appearing among the views in Beato's albums, evoked several extended associations, which, like kago images, were often-represented types in the same album.

In the autumn of 1864, two British officers, Major Baldwin and Lieutenant Bird

westerners who travelled the Tōkaidō. Wirgman's caption for this image rearticulated the relationship between the place and the event. He described a typical execution in all its gruesome details, but he also included the following passage:

> The view represents the execution ground, about a couple of miles from Yokohama, where the murderer of Major Baldwin and

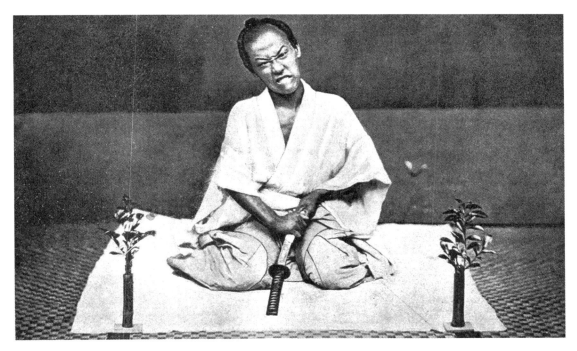

Fig. 15 *Harakiri*, from Sir Edwin Arnold, *Seas and Lands* (New York: Longmans, Green and Company, 1891), p. 222.

were murdered when they crossed the path of the *daimyo* of Satsuma *han* as his entourage was travelling the Tōkaidō in the vicinity of Yokohama. Shimizu Seiji was arrested for the crimes and beheaded at the execution ground near Shinagawa. Beato later recreated Shimizu's execution in his studio (fig. 14). Knowing the relationship of this historical event with the execution grounds, Beato acquired a few props to set the appropriate scene, including a painted backdrop featuring Mount Fuji – a sight frequently encountered by

Lieut. Bird – the notorious Shimidzu Seiji – was executed in December 1864.[24]

In other words, both Wirgman's caption and Beato's photograph linked the locale to the historical event by collapsing a view and a type into a single image.

What, then, are the implications of this practice for albums produced in the 1880s and '90s? Travel narratives often employ the same juxtaposition of place and historical event (i.e. view and type) demonstrated in Beato and

Wirgman's treatment of the executioner. In 1874 Griffis wrote: 'The Yankee has invaded the Land of the Gods. He jostles the possessions of the lords of the land. He runs a coach on the great highway, so sacred to daimios and two-sworded samurai.'[25] Henry Faulds, writing in the 1880s, noted that the highway had fallen into disrepair through neglect. He wrote: 'You cannot read very much of a good old romance without finding yourself "located", as Yankees say, on some part of this thoroughfare, or at least on one similar to it, where so much of the romantic life of knightly activity of the ancient empire found its expression.'[26] R.B. Peery's 1897 *The Gist of Japan* included the following: 'Some of the chief highways are very old. The most famous is the Tōkaidō, extending from the old capital,

Kyoto, the seat of the imperial court, to the city of Yedo (now called Tokyo), the seat of the shogun's government. It was over this road that the ancient daimios of the western provinces used to journey, with gorgeous pageantry and splendid retinues to the shogun's court.'[27] The Tōkaidō became a necessary element in travellers' accounts, in part because it remained within the scope of their lived experience, but clearly, its significance also lay in its historical associations with the *daimyo* and samurai of Japan's feudal past.

The fascination with samurai in travel narratives emerged at a time when they had virtually disappeared. Edicts passed by the Meiji government in the early 1870s effectively legislated the former ruling class out of existence, but at this point commercial

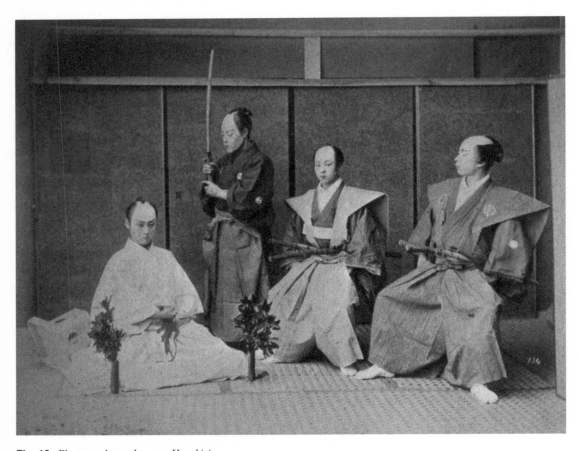

Fig. 16 Photographer unknown, *Harakiri*.

photographers began producing studio-posed photographs of models dressed as samurai. Much like Beato's restaging of the Shimizu execution, they went so far as to photograph re-enactments of *seppuku*, complete with artificial blood. Travel writers supplemented their accounts with these images (fig. 15). Tourists included them among the types in their albums (fig. 16). In other words, just as Beato collapsed view and a type into a single image with his re-enactment of Shimizu's execution, late-nineteenth-century travellers performed exactly the same act when they juxtaposed in both their albums and travel narratives views representing their personal experiences with studio-posed photographs of samurai performing *seppuku*. Albums wrapped views and types into a single package. And no matter how far-fetched the types might be, they seamlessly entered the narrative sequences posed by the albums and validated by the consumers who selected them.

Travel as text – consumer as photograher

When added to an album, photographs of the places a tourist actually visited facilitated re-narration of their personal experiences and, in the process, negated the need for extensive captions of the sort Wirgman provided for Beato's albums. This change in protocol represents, in fact, a powerful reconfiguration of the way images in albums functioned. Although Wirgman's captions often imposed highly specific readings on images, they also gave them a measure of independence in the sense that they created micro contexts that enabled each image to stand on its own irrespective of its place in an album. If extracted from an album along with its caption, individual images were more than capable of producing meanings even a marginally informed viewer could readily grasp. Albums of the 1880s and '90s were different in that the meaning of individual images was dependent on their place in a sequence linked to the personalised itinerary of a traveller. Because of

the implied presence of the tourist, the meanings generated by images in later albums blurred the distinctions between artist and viewer (producer and consumer) that seem so evident in Beato's albums.

Travellers of the 1880s and '90s did not create the actual photographs – commercial photographers peered through the camera lens, framed the shot, then developed and printed the image. But processes within the practice of commercial photography facilitated the seamless fusing of personal experience with an image to which the tourist could make no direct claim of authorship. The selection of an image from the vast inventories commercial studios maintained was the first step in this process. The fact that consumers were offered choices had the effect of putting them behind the camera. And when the image they chose was added to an album and sequenced to their travel itinerary, the actual producer of that image slipped further out of view. We can be reasonably certain that when travellers re-narrated their albums, their comments would not include: 'and this was the photograph I purchased from Kusakabe Kimbei's Yokohama studio'. One expects, rather, something more like 'and as I wound my way through the cypress groves of Nikkō, I suddenly came upon the spectacular gate of the Tōshōgū Shrine'.

The consumers of late-nineteenth-century commercial photographs rarely appear among the images they collected for their albums but their expectations, desires, predilections, preferences and sensibilities are ever present in every image of every album. As scholars aspiring to thoroughness and accuracy, we need to bring these consumers into focus and put them back into the picture of the histories we create.

Notes

1 Strictly speaking, J.G. Gower, an amateur photographer attached to Sir Rutherford Alcock's diplomatic mission, may have been responsible for the first album of Japanese photographs. Several of Gower's images were published in album format by

the firm of Negretti and Zambra upon his return to England in 1861. This album was not widely available, however, and probably had little effect on the subsequent development of the album in Japan.

2 Both ads are illustrated in Yokohama Kaiko Shiryōkan, ed., *Bakumatsu Nihon no fūkei to hitobito: Ferikkus Beato shashinshū* (Tokyo: Akashi Shoten, 1987), p. 170.

3 The Royal Photographic Society, Bath possesses this photograph. It is reproduced in John Clark, ed., *Japanese Exchanges in Art 1850s to 1930s* (Sydney: Power Publication, 2001), fig. 8.

4 Beato met Wirgman, a correspondent for the *Illustrated London News*, in China in 1860, where both were covering Lord Elgin's mission to Beijing. Wirgman travelled to Japan, again with the Elgin mission, arriving in Nagasaki on April 25, 1861. (He filed his first dispatch from Japan for the *ILN* on May 19; it subsequently appeared in the August 10 edition). Recognising the potential for commercial photography in Japan, Wirgman extended an offer to Beato to become a partner in a photography business in Yokohama, the most important of the newly opened treaty ports. It is not known precisely when Beato arrived in Japan. The earliest reliable confirmation of his presence is an *ILN* dispatch filed by Wirgman on July 13, 1863 (published in the September 26 edition). It mentions that many Japanese frequently visited his Yokohama residence to see his sketches and Beato's photographs.

5 Wirgman began publishing the *Japan Punch*, a humourous English-language magazine for residents of the treaty ports, on an intermittent basis in 1862. By 1873 it had become a monthly, continuing publication to March 1887.

6 Anecdotal evidence supports this assessment. Among his first impressions of Yokohama upon his arrival in 1870, William Griffis, noted that: 'Photographic establishments tempt our eyes and purse with tasteful albums of Japanese costume and scenery.' See William Griffis, *The Mikado's Empire* (New York: Harper and Brothers, 1876), p. 344.

7 This ad is illustrated in Yokohama Kaiko Shiryōkan, ed., *Bakumatsu Nihon*, p. 9.

8 Recent research has documented the existence of hundreds of commercial photographers working in the 1870s, '80s, and '90s. See Torin Boyd and Naomi Izakura, *Portraits in Sepia* (Tokyo: Asahi Sonorama, 2000).

9 The Peninsular and Oriental SS companies competed with the Pacific SSC for local routes until the Mistubishi Steamship Company bought out the Pacific SSC and used its monopoly, granted by the Japanese government, effectively to end competition.

10 These developments prompted William Griffis to remark in the early 1870s: 'Already the circummundane tourists have become so frequent and temporarily numerous in Yokohama as to be recognised as a distinct class.' See Griffis, *The Mikado's Empire*, p. 339.

11 Arthur Crow, *Highways and Byways in Japan* (London: Sampson Low, Marston, Searle, and Rivington, 1883), pp. 65–66.

12 Satow and Hawes's guide had 20 advertisements for 500-plus pages of text. Keeling's guide had 41 ads for 92 pages of information.

13 Douglas Sladen, *Club Hotel Guide to Japan* (Yokohama: The Club Hotel, 1892), pp. 12–13.

14 The 1880 edition of *The Japan Directory*, for example, included advertisements by Baron Stillfried and Usui. For illustrations see: Yokohama Kaiko Shiryōkan, ed., *Meiji no Nihon: Yokohama shashin no sekai: saishiki arubamu* (Yokohama: Yurindō, 1990), p. 227.

15 For example, once cameras became more readily available and a common accessory in tourist kits, commercial studios began offering darkroom facilities to amateurs.

16 Beato began his career in the Mediterranean where commercial photographers commonly utilized the views and costumes dichotomy.

17 Studios sometimes mounted a photograph into the actual cover.

18 For westerners travelling to Japan by way of China or South East Asia, Nagasaki was often their first point of disembarkation. Some of Beato's pre-made albums open with photographs of Nagasaki in order to reflect this option.

19 Eliza Scidmore, *Jinrikisha Days in Japan* (New York: Harper and Brothers, 1891), pp. 189–190.

20 Arthur Crowe mentions Satow and Hawes on several occasions in his 1883 *Highways and Byeways in Japan* and often quotes their descriptions. See Arthur Crowe, *Highways and Byeways in Japan*, pp. 36–37, 112–114, 133–134, 180–189. Henry Faulds also deferred to Satow and Hawes for a description of Nikkō. See Henry Faulds, *Nine Years in Japan* (Boston: Cupples and Hurd, 1888), p. 160.

21 William Griffis, *The Tokio Guide* (Yokohama: F.R. Wetmore, 1974), pp. 30–32.

22 Aimé Humbert, *Japan and the Japanese Illustrated* (New York: D. Appleton, 1874), pp. 147–164.

23 Kaempfer also mentioned the execution grounds each time he passed them, going to and coming from Edo.

24 Quoted from an album in the possession of the New York Public Library.

25 Griffis, *The Mikado's Empire*, p. 353.

26 Faulds, *Nine Years in Japan*, p. 42.

27 R.B. Peery, *The Gist of Japan* (New York: Fleming H. Revell, 1897), p. 16.

PORTRAYING THE WAR DEAD

Photography as a Medium for Memorial Portraiture

Kinoshita Naoyuki

Fig. 1 Hiroshima National Peace Memorial Hall for the Victims of the Atomic Bomb.

This essay discusses the emergence of the genre of portraits of the war dead in late-nineteenth-century Japan, with particular emphasis on the role of photography. Before discussing these issues, I would like to explain briefly how I became interested in representations of the war dead, a subject which seems to have recently begun to attract greater attention in Japan. It is quite surprising to see such a surge of public interest in this politically sensitive issue, especially considering that nearly 60 years have already passed since Japan's defeat in World War II. There are fewer and fewer survivors of that war today, and its memory is wearing thin with time. Understandably the value of documentary photographs as a memorial to the tragedy is increasingly recognised, however it is particularly intriguing that portraits of the war dead are also attracting people's attention. As a starting point for an exploration into this development, the display of the Hiroshima National Peace Memorial Hall, which was newly opened last summer, will be taken into account (fig.1).

Before examining the display of the Hiroshima National Peace Memorial Hall, it is important to clarify the meaning of the term *senbotsusha* (the war dead). In contemporary Japanese there are at least three terms that refer to war casualties: *senshisha*, *senbotsusha* and *shibotsusha*. Although all three terms refer to war casualties, they in turn refer to different categories of death. *Senshisha* refers to those

the most generic of the three, it has a special usage in reference to those killed by the atomic bombs dropped on Hiroshima and Nagasaki in 1945. By putting the term *genbaku* (atomic bomb) and *shibotsusha* together a new phrase *genbaku shibotsusha* was coined. This is often translated into English as simply 'victims of the atomic bomb'.

The Japanese government treats these

Fig. 2 Hiroshima Peace Memorial Museum.

killed in action or in the line of duty. The majority of the *senshisha* are military officers and professional soldiers. The term *senbotsusha* is occasionally used in the same way as *senshisha*. However, *senbotsusha* also includes people killed in locations other than the battlefield, in addition to those who died in the line of duty. For example, civilians and non-combatants killed by an aerial attack would be termed *senbotsusha*.

The third term *shibotsusha* literally means 'the dead'. Though this term may appear to be

three categories of death separately. In other words, the government's point of view differs concerning the manner and significance of death in each of these categories. In addition, the government sets up different levels of compensation for each category of death. For example in the case of *senshisha*, those who were killed in the line of duty, the government guarantees a pension to the bereaved families. The deceased in this category are therefore officially identified by the government.

Senbotsusha technically include both

Fig. 3 Portrait photographs of the dead, and survivors' testimonies, Hiroshima National Peace Memorial Hall for the Victims of the Atomic Bomb.

civilians and military personnel. However, the government does not guarantee any compensation to the families of civilians killed during the war. In place of monetary compensation, annual commemoration ceremonies have been held by the government since the end of the Allied Occupation in 1952.

In the third category of *shibotsusha* only *genbaku shibotsusha* (victims of the atomic bomb) became eligible for compensation when the *Hibakusha* Aid Law (*Hibakusha engohō*) was enforced in 1994. However, only *hibakusha*, the living survivors of atomic bomb, are covered by this law. Article 41 of the *Hibakusha* Aid Law covers those killed by the atomic bomb, and reads:

> In order to remember the sacrifice of *shibotsusha* and to pray for eternal peace, a number of projects will be undertaken. The projects will aim at deepening the nation's understanding of [the danger of]

the atomic bomb, passing down the memory of the atomic bomb for posterity and mourning the *shibotsusha*.

Following stipulations in the *Hibakusha* Aid Law, the Hiroshima National Peace Memorial Hall for Atomic Bomb Victims and the Nagasaki National Peace Memorial Hall for Atomic Bomb Victims were inaugurated on 1 August 2002. I am not sure what kind of impression the English names of these Memorial Halls provide, but in Japanese the official names are long-winded, overtly political and awkward-sounding. In reality, by building these museums, the government established an apparatus for preserving collective memory instead of granting compensation to individual victims.

Another museum with a similar objective to the Hiroshima Memorial Hall is the Hiroshima Peace Memorial Museum (fig. 2), which was established in 1955 by Hiroshima

City. The displays consist mainly of household possessions of the victims and objects such as pieces of metal and glass melted by the heat of the atomic explosion. These objects are put on display in order to remind us of the horrific power of the atomic bomb.

Almost half a century after the inauguration of the Hiroshima Peace Memorial Museum the government set up the Hiroshima National Peace Memorial Hall. Since the Memorial Hall is in close proximity to the Hiroshima Peace Memorial Museum, it has been criticised as superfluous and somewhat analogous to 'putting a fifth wheel on a coach'. In fact, it proved to be extremely difficult to acquire items belonging to victims of the atomic bomb. Instead, the government elected to build its collection around portrait photographs of the dead, and survivors' testimonies (fig. 3).

The two museums present a sharp contrast. While the Hiroshima Peace Memorial Museum focuses on the display of physical objects, the Hiroshima National Peace Memorial Hall aims at providing intangible information through images, words and messages.

The Memorial Hall is composed of two parts: a room with computer terminals and a non-religious commemorative space with water running through the middle. To some extent, it is understandable that the state selected such a non-religious design for the commemorative space since the Japanese Constitution prohibits the state from being affiliated with any specific religious institution. I believe, however, that there are few Japanese who could actually mourn the dead in such a non-religious atmosphere.

Regarding the computer room, all the portrait photographs and testimonies in its collection are digitized, in order for visitors to easily access them. For example, if I type my family name, Kinoshita, into a computer, the portrait photographs of all the Kinoshitas in the collection immediately come up in succession on the screen. If you choose one of the Kinoshitas and click the option of 'those who died in the same place', another selection of

portraits appears on the screen. The same is true when you click the option of 'those who died at the same age'.

Through the computers, the Memorial Hall provides us with easy access to information on the vast number of the war dead. However, a simple question comes to mind: is this really an appropriate place to mourn the dead and pray for eternal peace? While the Memorial Hall continuously provides us with a flow of information, it does not seem to question whether or not the visitor is able to critically receive such vast amounts of information and thereby understand the message the Memorial Hall intends to convey.

Similar displays of portrait photographs have been developed by museums dealing with war and the Holocaust in Europe, Canada and the United States. As can be seen through the

Fig. 4 Yūshūkan Museum, Yasukuni Shrine.

example of the Hiroshima Memorial Hall, Japanese museums have recently begun to learn from their overseas counterparts. Not only the Hiroshima and the Nagasaki Memorial Halls, but also the newly renovated museum attached to Yasukuni Shrine in Tokyo exhibits portrait photographs.

In 1882 a museum to display the history of war was created at the Yasukuni Shrine. This museum was named the Yūshūkan. It is one of the oldest museums in modern Japan along with the Imperial Museum set up in 1889 in

Ueno Park and renamed the National Museum in 1945. The Yūshūkan was built in a European style, designed by the Italian architect Giovanni Capalletti, on behalf of the Japanese government (fig. 4).

Yasukuni Shrine itself was inaugurated in 1869 and initially named Shōkonsha (*shōkon* means to invite spirits of the dead). It was originally created as a commemorative site for those killed in the line of duty after the Meiji Restoration of 1868. The Yasukuni Shrine was then a national institution under the direct supervision of the military. Currently, the Yasukuni Shrine is an official religious institution and therefore not under government control. The Yasukuni Shrine houses the national roster of all the Japanese war dead. The most important ritual performed at Yasukuni Shrine is the *shōkonshiki*. During this ritual the names of the war dead are written on the roster. Once the ritual is finished, the war dead recorded on the roster are recognised as divine spirits or *saishin*. The main hall (*honden*) of the shrine is a space used only for storing this roster, and there is no mortuary tablet (*ihai*) or portrait photograph as usually seen in Buddhist temples. The roster has recently been digitized.

The Yūshūkan is a museum attached to Yasukuni Shrine, and since its founding in 1882, it has played an important role in giving historical meaning to the death of soldiers. During its early days, the Yūshūkan mainly displayed weaponry to demonstrate the historical development of arms in Japan, and the history of Japanese warfare. The weapons used by soldiers in modern-day wars were also displayed along with these historical objects. In so doing, the soldiers' deaths were given a legitimate place in the history of Japan. As Japan began to experience international warfare, most notably in the Sino-Japanese War in 1894–5 and the Russo-Japanese War in 1904–5, a number of war trophies began to be important exhibits in the Yūshūkan.

Fig. 5 New building for the Yūshūkan Museum, Yasukuni Jinja.

Japanese casualties in the Sino-Japanese and the Russo-Japanese Wars far outnumbered those of the previous wars. However, articles left by these war dead were rarely exhibited in the Yūshūkan, with the exception of objects left by outstanding war heroes. As far as remaining records attest, the oldest example of such an object was the uniform of Major General Odera Yasuzumi who died on 2 September 1895. The uniform was on display until December 1895.

One might think that portrait photographs of the war dead would have occupied an important part of the Yūshūkan collection, since the Yūshūkan was the oldest war museum in Japan. However, the main body of the Yūshūkan collection consisted of weaponry and articles of the war dead. It appears that the Yūshūkan never intentionally collected photographs of the war dead.

In 2002, the Yūshūkan underwent a major renovation (fig. 5). As with all such endeavours, there always has to be a reason for such a large-scale refurbishment. As the number of survivors of World War II are decreasing as the years go by, and so living memory of the war is also passing, the refurbishment of the Yūshūkan resembled a new means to preserve and visualise the memory of war. The original displays of the Yūshūkan relied heavily on the living memory of war, and this approach needed to be quickly re-addressed.

In response, the Yūshūkan acquired numerous portrait photographs of war dead for display. In the newly reconfigured exhibition area a number of individual portraits are arranged in groups. In this fashion the Yūshūkan is attempting to convey the message that a large number of young people died on the battlefield. However, I wonder if visitors to the museum, as well as those to the Memorial Hall might end up being merely overwhelmed by the numerous images of the dead, and thus deprived of an opportunity to think critically about what is behind the visual image – the war itself.

It is difficult to reconstruct the conditions surrounding the nineteenth century Yūshūkan collections as they were badly damaged on two occasions, firstly by the Great Kantô Earthquake of 1923, and secondly by an American aerial attack in 1945. The oldest portrait photograph surviving in the collection is an image of wounded government military officers during the Satsuma Rebellion of 1877. Although this photograph is recognised in the genre of portraiture today, originally it would have been viewed as a medical document. Everyone depicted in this photograph struck a particular pose in order to display to best advantage the wounds apparent on their bodies. A number of watercolour paintings produced for similar medical purposes are also known to exist.

This particular example of a medical document was produced by a photographer who operated in Osaka where the Temporary Military Hospital was located. Oddly enough, the photograph features some of the props frequently used in regular portrait photographs, presumably because it was taken by a civilian photographer. The officers are all pictured in exaggerated poses, which would have been unnecessary for simply a medical document. The Yūshūkan owns a number of photographs of wounded soldiers taken during the Russo-Japanese War. Unfortunately, the reproduction of these images is strictly prohibited, as Yasukuni Shrine considers publication an invasion of privacy of the soldiers and their families. These photographs of wounded soldiers are mounted in luxury photo albums in groups of three. The first image in the three-photograph set shows a wounded soldier who appears to be naked. The same soldier is photographed with an artificial arm or leg in the second image. In the third and final photograph, he appears fully dressed in military uniform. In short, one set of photographs depicts the same person in three different stages, and thus visualises the regeneration of injured soldiers. In that period the government would provide wounded soldiers with artificial arms and legs on the

Fig. 6 *Shintenfu* (war trophy store house).

premise that they were offered by the emperor. Therefore, this set of photographs clearly demonstrates the process through which soldiers who had been injured for the sake of the emperor were physically 'regenerated' by the emperor. They are clearly not simple medical photographs, rather, they should be termed 'political photographs'.

In modern Japan, as the head of the Japanese Imperial military, the emperor officially despatched soldiers to the battlefield. Therefore, an interpretation of the representation of war dead necessitates an examination of its relationship to the emperor. As mentioned above, Yasukuni Shrine preserves photographs of wounded soldiers but it does not devote any attention to photographs of the war dead. This fact poses the question as to whether or not the images of the war dead reached the emperor, and if so, how were they presented to him?

In modern times, Japanese emperors often make political statements in the form of a

waka (a style of Japanese traditional poetry). These Imperial poems are specifically called gyosei. There is one gyosei entitled 'photograph' composed by the Meiji emperor in 1906. It reads as follows:

> They lost their lives
> For the sake of the Nation
> Their pictures we display
> So at all times we can admire
> Their heroic courage.

The poem indicates that portrait photographs of the war dead did indeed reach the emperor. This possibility is further substantiated by the following report about the imperial storage house. When the Sino-Japanese War ended in 1895, the imperial family built a storage house to preserve war trophies. It was known as the Shintenfu (fig. 6). Whilst the majority of the war trophies stored in the Yūshūkan consisted of weaponry, the Shintenfu acquired not only

weapons, but also a number of precious objects such as sculptures of lions and luxurious chairs. Included was an oil painting by Kawamura Kiyō depicting a scene of war trophies being brought into the Shintenfu. Photographs showing the exterior of the Shintenfu also survive. However no image of the interior has yet been discovered. Even after the Sino-Japanese War the Shintenfu collection continued to grow, so much so, that an annex was built every time Japan participated in a war.

A limited number of people were permitted to visit the Shintenfu. One visitor, a journalist, reported on the inside of the Shintenfu after his visit in 1902. According to this report, the Shintenfu was not merely a storage house but also a commemoration site for the war dead. The Shintenfu, the report goes on to state, enshrined huge portrait photographs to commemorate the officers as well as a roster for ordinary soldiers. The report also concluded that the portrait photographs of the officers had been collected on short notice. Therefore, not every photograph portrayed the officers in military uniform. Some photographs captured the officers in *wafuku* (Japanese-style clothing). Such inconsistency in display reveals that the enshrinement of portraits of the war dead had not yet been fully institutionalised by this stage. Moreover, two different formats for the portraiture indicate that portraits of the war dead were embraced by the public in two stages, depending on the rank of the deceased.

The same transition can also be witnessed in contemporary publications. Periodicals began to feature portrait photographs of officers and, later, those of ordinary soldiers. While the display of portrait photographs occurred in phases at official commemorative institutions such as the Yūshūkan and the Shintenfu, periodicals began to publish portrait photographs during the Sino-Japanese War all at once. One such example is that of the *Nisshin Sensō Jikki* (the Record of the Sino-Japanese War), a magazine published by Hakubunkan. This quarterly magazine was inaugurated in August 1894, and 50 issues had already been published by January 1896. The magazine introduced to the general public various events concerning the Sino-Japanese War as it was occurring through photographs and illustrations. The first eight issues carried six portraits of war dead (fig. 7). The number subsequently increased and 66 portraits were featured in the last issue (fig. 8). Sales of the magazine appears to have grown in large part because of the growing popularity of portrait photographs of the war dead.

Two conditions enabled the rapid popularisation of portrait photographs in the mass media. The first was technology. By the time of the Sino-Japanese War, it was finally possible to create photographic reproductions on a large commercial scale in Japan. With the development of printing technology, photographic images became a regular feature in newspapers and periodicals. The second factor was the establishment of a conscription system that widened the readership of war magazines. Until the 1860s there was no universal conscription system in Japan, and only professional soldiers known as *bushi* actually fought in battle. From the 1870s onward, the Japanese government embarked on the foundation of the modern conscription system. It was, however, only in the 1890s that the conscription system was enforced after several amendments. Conscription signified the arrival of a new age in which more or less the entire nation went to war. The Sino-Japanese War was the first such national war in which the new Japanese military confronted a foreign enemy.

All families who sent loved ones into the battlefield would have been avid readers of war magazines. These war magazines, in turn, played a crucial role in transforming the place of portrait photography in society. In short, portraits of the war dead, which previously were only valued by the bereaved, acquired wider public recognition through the mass media during the Sino-Japanese War.

By themselves, however, these war

magazines were not powerful enough to permanently establish the genre of war dead portraiture in society, since their influence on readers was only temporary. To secure the position of portraits of war dead, a regular commemoration ceremony for displaying them and an official site for permanently preserving them were essential. The Shintenfu, which I introduced earlier, would have functioned as such an official site, although it is unknown whether or not a regular commemoration ceremony was held there.

I recently discovered that Tokyo University held a commemoration ceremony in 1907 for university students killed in the Russo-Japanese War. During this ceremony portrait photographs of the students were displayed in the university library. These photographs were placed in a special and rather un-Japanese frame designed by the architect, Tsukamoto Yasushi. After the ceremony the photographs continued to be enshrined in the library. At that time Tokyo University was run by the state, and was named the Imperial University. It was only 11 years after the inauguration of the Shintenfu when the Imperial University held this commemoration ceremony. Other official organisations and institutions supposedly would have followed in the footsteps of the Imperial University and created specific sites for enshrining and preserving portrait photographs of war dead. Part of my ongoing research plan is to uncover how these memorial sites came into being.

Photography thus became the new medium for memorial portraiture. Japan had a long tradition of painted and sculpted memorial portraits. Whether portraits were made before or after the death of a subject, they were created as substitutes for the deceased in some fashion. Such portraits were only commissioned by the elite, including political authorities, religious leaders and wealthy merchants. For example, portrait sculptures of feudal lords and their vassals were occasionally made after the subjects' deaths. One such example consists of sculptures of seven vassals who committed suicide following the death of their master, being half the size of the memorial sculpture made of their lord. It almost seems as if they were seven dwarves sitting closely together around their master. The difference in size, of course, symbolises the class distinction between the lord and the vassal. Together with the vassals' bowing posture, these sculptures indicate that the class division in this world continued even in the hereafter. Ordinary people in traditional Japan usually did not commemorate the deceased with images, but rather with names by bestowing a Buddhist name (known as *kaimyō*) upon the dead. Therefore, a mortuary tablet (*ihai*) onto which the *kaimyō* is written possessed a great deal of importance in Japanese society.

Recently a memorial sculpture commissioned by the master of a wealthy merchant family to commemorate his father and enshrined inside the house has come to scholarly attention. The main body of the sculpture is simply made of wood, but a number of details have been applied in order to invoke the memory of the deceased. For example, the sculpture had real human hair applied and eyes made of glass. Moreover, specific items worn and carried by the figure, including his *kimono*, a fan and *hibachi* (Japanese heating appliance), were all objects used during his lifetime. Since portraits of commoners have not traditionally been regarded as high art, sculptures such as this have been neglected by art historians.

Interestingly, while the production of memorial portraits has a long history in Japan, portraits of the war dead were rarely produced. Paintings of soldiers in battle spotlighting their fearless actions that led to death were the preferred medium. In short, images of soldiers just before death were the standard format of war images in Japan.

As is widely recognised, advanced woodblock printing techniques were generally available in nineteenth century Japan. Among

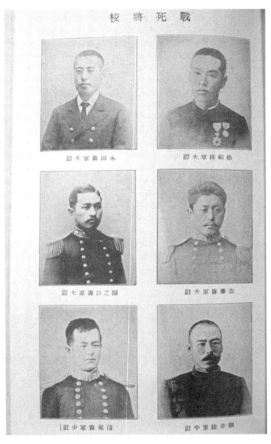

Fig. 7 *Nisshin sensō jikki* (Record of the Sino-Japanese War), volume 8, showing portraits of the war dead.

Fig. 8 *Nisshin sensō jikki* (Record of the Sino-Japanese War), vol. 50.

the most popular subjects in that period were heroic battle scenes depicting samurai warriors known as *musha-e* (pictures of warriors). Since no actual warfare occurred in Japan during the early nineteenth century, the majority of *musha-e* dealt with legendary heroic stories of the distant past. But even if there had been a war, government regulations strictly prohibited the production of straightforward depictions of contemporary conflicts or political affairs.

Wars of various scale broke out all over Japan during the 1860s. From 1868 to 1869, the biggest domestic war, the Boshin Civil War occurred, and as a result the Tokugawa feudal government subsequently collapsed. Around the same time Japan also came into conflict with a number of Euro-American countries.

These domestic and international wars were all visualised as they were occurring.

For example, one newspaper illustration depicted a scene in which the allied forces of Britain, France, Holland and the United States attacked the Chōshū Domain in southern Japan. The newspaper incorrectly reported the attack by allied forces as causing a large fire. The very fact that this event was at least reported, even though camouflaged as a fire, indicates that information circulation was beyond the government's control. It is also notable that the fight between the allied forces and the Chōshū Domain was widely covered in the *London Illustrated News*, showing that the Japanese government could no longer prevent the intervention of western mass media in the 1860s.

Fig. 9 Broadsheet recording the Great Fire of Ueno (*kawaraban*).

In another example, two woodblock prints depict a battle that occurred in Edo (now Tokyo) nicknamed the Ueno War. Supporters of the Tokugawa feudal government barricaded themselves in the Tokugawa family's sanctuary, the Kanei-ji Temple in Ueno, in order to escape the emperor's militia. The first of the two images is a contemporary broadsheet illustration of the Ueno War. In a similar fashion to the newspaper that reported the Boshin Civil War, this broadsheet announced that a large fire had broken out in Ueno (fig. 9). The second image depicts a heroic representation of the vanquished Tokugawa supporters from the Ueno War, which was published in 1874 exactly six years after the event, as the crimes of the defeated forces were believed to be exonerated on the seventh anniversary of their death (fig. 10).

In 1874, the same year in which the print of the fallen Tokugawa supporters was published, Matsuzaki Shinji, one of the earliest known official military photographers, recorded Japan's invasion of Taiwan. According to contemporary newspaper accounts these photographs were sold after Matsuzaki's return to Tokyo. Although these photographs are unavailable today, some pictures thought to be based on Matsuzaki's photographs have survived: an oil painting by Shimooka Renjō, and lithographs by Takahashi Yuichi and Nakamura Seijūrō. Based on these remaining images, Matsuzaki's photographs appear not to have been of battle scenes but group portraits of soldiers and landscapes taken during his stay in Taiwan. It was, of course, extremely difficult for photographers to capture a decisive or heroic moment on the battlefield. Therefore, painters were hired to portray heroic war scenes. In the following years *musha-e* woodblock prints depicting the Satsuma Rebellion, the Sino-Japanese and the Russo-Japanese Wars remained popular.

Another point I would like to stress is that

portrait photographs of war dead were popularised after the Sino-Japanese War in the late-nineteenth-century. They first reached the general public through mass media, followed by the establishment of official commemorative sites for preserving them and mourning the dead. At this stage, portrait photographs of the war dead no longer remained in the private sphere merely as mementos of the bereaved. They became a new means to represent the war symbolically without actually showing the battlefield.

I end this essay by introducing a proposal made by Takahashi Yuichi at the time when the use of portrait photographs was in a transition stage. Takahashi Yuichi was a pioneering painter who recognised the advantages of western oil painting and attempted to popularise its practice in Japan. According to Takahashi, painting in China and Japan was

Fig. 10 The cover of *Tokyo Nichinichi*, no. 689.

mere child's play, and only oil painting could be truly beneficial for society as it had the ability to represent the truth.

After the Satsuma Rebellion in 1877 Takahashi asked for permission to paint portraits of war dead. In his letter to the Chief Commissioner of the Metropolitan Police, Kawaji Toshiyoshi, Takahashi mentioned that in Euro-American countries people who rendered distinguished service to the state were all visualised in painting or sculpture and remembered for generations. When Takahashi made this proposal the Shōkonsha (later the Yasukuni Shrine) had been already established. However, it was a site for pacifying the spirits of the dead rather than memorialising them, a site where the names of the war dead were merely recorded. Takahashi insisted that the best way for the war dead to be remembered by successive generations would be through the medium of images. Furthermore, Takahashi maintained that the war dead should be represented in portrait form, and not in the heroic actions often depicted in *musha-e*. Takahashi probably considered *musha-e* too exaggerated and imaginary, and therefore not a faithful representation of reality. In other words, Takahashi attempted to paint portraits of the war dead in an 'un-heroic' way.

According to records, the Yūshūkan originally housed at least two portraits of war dead by Takahashi Yuichi. However, both of these were portraits of military officers from aristocratic families. The paintings were not of the dead who would have been mourned by ordinary citizens. Moreover, portrait photographs of war dead were never of central importance to the Yūshūkan collection. It was not until the number of the war dead rapidly increased with the Sino-Japanese and the Russo-Japanese Wars that portrait photographs of war dead gained widespread public recognition.

Translated by Kaneko Maki

'ELEGANCE' AND 'DISCIPLINE'

The Significance of Sino-Japanese Aesthetic Concepts in the Critical Terminology of Japanese Photography, 1903–1923

Mikiko Hirayama

One of the major preoccupations for early Japanese photographers was how to divorce photography from the realm of technology and establish it as a legitimate art form equal in status to painting. The rise of 'Art Photography' (*geijutsu shashin*), the Japanese equivalent of Pictorialism, intensified this struggle at the turn of the century (fig. 1). Leading art photographers and their contemporaries frequently discussed the status of their medium in specialised journals during the first few decades of the twentieth century. In their articles, authors often revisited concepts that had originated in pre-modern Sino-Japanese aesthetics, namely 'elegance' (*shumi*) and 'discipline' (*shūyō*).[1]

This paper analyses the ways in which these early twentieth century photographers appropriated Sino-Japanese aesthetic concepts through their writings in order to legitimise their own medium.[2] I will argue that these photographers intentionally re-used such traditional terminology in a new context, hoping that it would bring their points closer to home for their audience.

Analysis of these aesthetic concepts is challenging since they were rarely given clear definitions, but it will make important new contributions to studies of Japanese photography. The very absence of definitions indicates that these concepts were an integral part of contemporary culture and needed no explanation

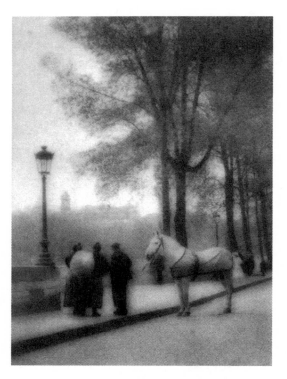

Fig. 1 Fukuhara Shinzō, *Horse Dealer*, 1913, from Ozawa Takeshi, ed., *Nihon shashin zenshū* vol. 2: *Geijutsu shashin no keifu* (Tokyo: Shōgakukan, 1986), p. 34.

to contemporary readers. Decoding them, therefore, will allow us to reconstruct the intellectual climate in which photography was established in Japan. It will also be a significant step toward what the historian of photography Douglas R. Nickel calls 'the study of photography as an idea,' a virtually

uncharted territory in the history of Japanese photography which will hopefully lead us to a fuller understanding of the subject.[3]

One extremely useful tool in this endeavour is contemporary photography periodicals. The growth of photography in Japan was heavily indebted to the power of the mass media. Periodicals devoted to photography, the earliest of which was launched in 1874, played an extremely important part in disseminating a variety of information about this new medium.[4] Major topics included technical instructions, news about group exhibitions, and articles on contemporary European photography. In these journals art photographers and their contemporaries found an ideal venue for publicising their ideas about the artistic potential of their medium.

Although their approaches to photography were by no means uniform, many art photographers shared the same concern about the place of photography in contemporary Japanese society. They often encouraged their peers to cultivate a breadth of knowledge and a respectable character instead of a preoccupation with technique. They also stressed the superiority of amateur photography over professional photography. In the commonly adopted rhetoric, photography was considered to be an art form capable of expressing 'elegance' as well as presenting a true-to-life image of an object. In many cases amateurs were considered to be better suited to elicit this potential in photography since they were expected to possess more elegance and discipline than professionals. As we will see, *shumi* and *shūyō* became important keywords in such arguments.

Shumi and *shūyō*, like many other Sino-Japanese aesthetic concepts, defy clear-cut definitions; the following definitions are meant to be strictly provisional. *Shūyō* means the acquisition of knowledge, especially practical studies such as politics, economics, and law, for the public good.[5] This concept originated in Confucianism, a system of thought which advocated each individual's contribution to public welfare in the manner appropriate to his or her respective social rank. *Shūyō* had a special resonance among the ambitious young Japanese of the late-nineteenth-century, who were eager to study the latest western natural and social sciences so as to contribute to state-wide modernisation projects and make a name for themselves. Later, early twentieth century photographers came to regard *shūyō* as an important ingredient of ideal artisthood.

Shumi is a rather complex term with multiple meanings. It is generally translated as 'taste' or 'hobby', though it has a broader meaning that may be translated as 'elegance', 'sentiment', or 'charm'. I contend that the authors of most of the articles discussed below interpreted shumi as 'elegance'. The concept of 'elegance', though usually denoted by another word, *ga*, was one of the highest ideals in Chinese and Japanese literati painting theory. It refers to insight into the intangible essence of the object that results from the painter's high moral character.

Literati painting originated in the art of court bureaucrats during the Northern Song Dynasty (907–1126) in China.[6] One of the focal points of its aesthetics was the superiority of spirituality over formal likeness. A painting was first and foremost expected to express the spirit or the moral character of the painter. Pictures by the literati would be considered elegant in so much as they were deemed to be expressive of the painter's exulted spirit. This was because, as amateurs, these artists painted purely out of their creative urge rather than financial necessity, and their pictures were therefore believed to be close reflections of their moral character. *Shūyō* was also an essential part of the lifestyle of the literati, who were expected to cultivate the arts and read widely in order to maintain their moral rectitude. On the other hand, overemphasis on physical likeness or technical finesse was despised as superficial and boorish. In China, especially from the Yuan Dynasty (1260–1368)

Fig. 2 Miyake Kokki, *House with Whitewashed Walls*, 1921, Shizuoka Prefectural Museum of Art.

onward, paintings by professional artists belonging to the court academy were considered to be inferior to the work of amateur painters. Such ideals also had tremendous impact on Japanese painters from the eighteenth century onwards.

The lasting impact of literati ideals on Japanese artists is indicated by the use of the word *shumi* to mean 'elegance' in essays by two western-style painters. The first, Takahashi Yuichi (1828–1894), a pioneering western-style painter in Japan, described in his autobiography his amazement at seeing a western lithograph for the first time during the mid-nineteenth century in the following terms: 'I found [the lithographs] to be extremely lifelike. And on top of that, I recognised *shumi* of sorts in all of them.'[7] Similarly, Miyake Kokki (1874–1954), whose essay is considered in more detail later, wrote in 1905: 'a painting that merely copied formal likeness but had no *shumi* is despised and described as 'like a photograph ...'[8] The ways in which *shumi* and

lifelikeness are contrasted in these quotations show that even western-style painters of the modern period continued to believe that representation of spirituality was the most important aspect of pictorial art. This approach to the visual arts was repeatedly appropriated by early twentieth century Japanese photographers in attempting to elevate their medium to the realm of the fine arts.

The position of photography in early twentieth century Japan was as yet rather precarious according to the accounts of two contemporaries: Miyake Kokki, the aforementioned watercolourist, who published an essay entitled 'My Hopes for Professional Photographers' in 1905 (fig. 2);[9] and the anonymous author known as 'Mr. Tripod', *Sankyakusei*. Mr. Tripod's editorial for the November 1903 issue of *Shashin shinpō* was entitled 'How We Should Improve the Quality of Photography in Japan'.[10] As we shall see, although Miyake and Mr. Tripod were not directly affiliated with pictorialism, their

essays bring to light many of the issues confronted by art photographers.

Both Mr. Tripod and Miyake observed that the aesthetic potential of photography had not yet been fully recognised in Japan. Moreover, they noted that photography was still considered as a form of business, and photographers as artisans, and neither believed that professional photographers had the power to change this situation. Because of the need to meet commercial demands, there was little room for creativity in professional work, which Mr. Tripod described as 'repetitious' and 'uninspiring.'[11] In any case, as Miyake noted, the majority of clients never paid much attention to the aesthetic quality of the photographs they purchased since most were satisfied so long as they went away with true to life images.[12] Such discrimination against photography was apparently rampant in the art world as well. Miyake's comment, quoted above, suggests that the very word photography could be used in a derogatory sense in contemporary art criticism.[13]

Although they were dissatisfied with the current state of photography, neither Miyake nor Mr. Tripod believed that emulating painting provided the ultimate solution.[14] Instead of appropriating painting, Mr. Tripod and Miyake endorsed the cultivation of *shumi* as the breakthrough needed to raise the status of photography and its practitioners. For instance, Miyake lamented the fact that contemporary photographers tended to pursue technical finesse at the expense of *shumi*. This was a shame, he said, because photography was not 'a simple skill' for replicating forms; rather, it was a medium with 'elegance (*shumi*) all its own', one that could convey the beauty of its subject matter just like painting.[15] Technical skill alone would not allow photographers to make the most of their medium.[16] Thus, Miyake recognised that the strength of photography lay in its ability to capture something beyond the physical form, and he described that quality with the word

shumi. In this respect, his ideas were almost straight adaptations of the statement by Takahashi Yuichi. Mr. Tripod addressed the same concepts when he drew a contrast between the work of professionals and amateurs. Mr. Tripod claimed to recognise more refined 'elegance' in the work of amateurs and less in that of professionals.[17] Evoking the concept of *shūyō*, he also urged professional photographers to cultivate a greater breadth of knowledge, especially science, and rely on their intellect rather than intuition and spontaneity in order to improve the quality of their work.[18] Despite their anti-pictorialist standpoint, both Miyake and Mr. Tripod thus appropriated the language that was traditionally used in the critique of East Asian painting to legitimize their advocacy of photography as an art form. This argument was also repeatedly adopted by art photographers.

Two early art photographers, who were contemporaries of Miyake and Mr. Tripod, lay

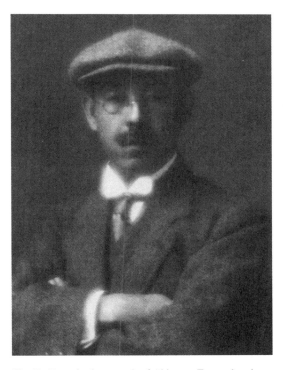

Fig. 3 Portrait photograph of Akiyama Tetsusuke, date unknown.

101

particular emphasis on the significance of *shūyō* in essays on the role of photographers as artists. Akiyama Tetsusuke and Katō Seiichi were the founding members of the Yūtsuzusha (Venus Society), the first art photographers' organisation in Japan formed in 1904 (fig. 3). Moreover, both were on the editorial staff of the journal *Shashin geppō*, to which they were regular contributors.[19] Inspired by pictorialism in Europe, art photographers maintained that photography was not merely a means of mechanical reproduction and sought to approximate the visual effects of painting in photography.[20] Akiyama summarised this standpoint as follows: 'We cannot recognise aesthetic value in straight reproductions of nature. Our goal is to express the sense of beauty [*bikan*] that nature transmits to us.'[21] In accordance with this philosophy, art photographers were to adopt well-calculated

Fig. 4 Akiyama Tetsusuke, *Morning Light*, 1927, from Ozawa Takeshi, ed., *Nihon shashin zenshū* vol. 2: *Geijutsu shashin no keifu* (Tokyo: Shōgakukan, 1986), p. 149.

composition, subtly diffused light, soft focus, and tinting and retouching of the negative or positive to achieve painterly effects (fig. 4).

Aside from these visual principles, Akiyama and Katō were particularly concerned with issues surrounding amateurism and the photographer's role as an artist. Once again, their model was European pictorialism, in which amateur photographers played a significant role. Quoting Herbert Spencer, Akiyama declared in an article of 1906 that the fine arts had a mission to educate the public and lead society to enlightenment.[22] He then lamented that many specialists failed to realise that photography had the same mission as the rest of the fine arts. In fact, he noted, quite a few of them even belittled their own medium as non-art and themselves as non-artists.[23]

In order to improve the status of photography, Akiyama and Katō urged their peers to strive for *shumi* and *shūyō*. For instance, they emphasised academic studies as an important part of training for photographers, and they scorned the preoccupation with technique, just as Mr. Tripod and Miyake had done. Katō contended that amateur photographers demonstrated more *shūyō* and *shumi* than professionals, and were therefore one step closer to ideal artisthood.[24] In the editorial of the January 1906 issue of *Shashin geppō*, Katō wrote:

> Not only do [the amateurs] have *shumi* all their own, they have the freedom to pursue their artistic endeavour to their hearts' content since this is not their means of livelihood ... most amateur photographers are very conscientious and continuously try to improve themselves. Furthermore, whereas professionals are generally plebeian and undereducated, amateurs are oftentimes more highly motivated and have more *shūyō*.[25]

Akiyama also advocated the importance of *shūyō* in his articles. He believed that in order

for photographers to become genuine artists, technical training alone was no longer enough. They would have to engage in the types of discipline that were specifically required of artists. He demanded that photographers 'become well-versed in physics, chemistry, mathematics and other subjects'.[26] What Akiyama ultimately expected of artists, however, was the 'cultivation of high morality and artistic concepts (*hinsei no shūyō* and *geijutsu shisō no shūyō*)':

> Even if the photographer had superb skills, if his character was not respectable, his work will never move the viewer. Therefore, photographers must seek to elevate their character in order to be truly recognised as artists.[27]

Upon closer inspection, a certain inconsistency in the image of the ideal artist envisioned by Akiyama and Katō for their fellow photographers may be apparent. Their goal of establishing photographers as artists was no doubt inspired by awareness of the status of the modern artist in Europe, which deeply affected Japanese painters at the turn of the century.[28] The ideas of ideal artisthood endorsed by Akiyama and Katō, however, were largely derived from Sino-Japanese concepts. While the idea of amateurism did exist in European pictorialism as well, the main points of their argument – discipline and elegance as the mark of amateur superiority – were clearly appropriations of literati doctrines.

My contention, however, is that this duality was not necessarily the result of their incomplete understanding of western ideas but of intentional hybridisation. Overlapping the amateur photographer, the ideal image of the literati artist, and the concept of modern artisthood would have been an effective rhetoric for art photographers for two reasons. Theoretically, it elevated the status of Japanese photographers by liberating them from the state of artisans. Moreover, despite the

seemingly western façade, these concepts would not have seemed completely foreign and were therefore relatively easy to digest for educated contemporary readers with some background in the early modern arts of China and/or Japan. In this way, the terms *shumi* and *shūyō* were given a new context and continued to play the key role in essays by early art photographers.

A later art photographer, Fukuhara Shinzō (1883–1948) also adopted a similar rhetoric although he moved away from the idea of discipline (fig. 5). He was a modern literati of sorts; he had a successful career as the president of cosmetics company Shiseidō but continued to be actively involved in photography, both in theory and practice, throughout his life.[29] In 1921 he launched a journal *Shashin geijutsu* (Photographic Art), to which he regularly contributed editorials and other articles. He also founded *Nihon shashinkai* (Japan Photographic Society) in 1924 and organised the first annual group show in the following year. His essay of 1922, 'Hikari to sono kaichō [Light and Its Harmony]', became known as one of the earliest sophisticated photography theories in Japan.[30] My analysis of his ideas centres on this essay and his radio lecture from August 1925 entitled 'Shasin no shumi' [Taste in Photography].[31]

Both Fukuhara's work and ideas were representative of the later stage of art photography, which broke away from the style popularised by Akiyama. He would consistently avoid retouching or trimming his image in favor of spontaneity and immediacy.[32] Sharing the views of Miyake and Mr. Tripod, he insisted that photography need not emulate painting. To him, the harmony of light, not form or colour, was the most important element in photographic art that truly distinguished it from painting:

> In order to recreate the beauty of nature [in photography], it is more effective to

see nature in terms of a collection of mass rather than investigate each object one by one. Tonal gradations arise from reflections of light on ... that mass, and when the photographer harmonizes these gradations [in his work], he would then succeed in recreating the beauty of nature.[33]

In his writings, Fukuhara consistently encouraged his colleagues to explore this harmony of light so as to make the most of the photographic medium.

The concept of *shumi* continued to figure prominently in Fukuhara's view of photography.[34] In his radio lecture, he explained that what he meant by *shumi* was 'the content, or the what, as opposed to the technique or the how.'[35] This somewhat cursory definition may seem to be contrary to the idea of *shumi* outlined above, but a closer look at his argument reveals that what he really meant was not quite the sheer content but something rather broader. For instance, he explained that an old photograph of himself as a child taken by his late father not only showed the image of a child but also evoked fond memories of childhood and touched him profoundly.[36] He also remarked that the photographer could convey '[his] sense of amusement' that is evoked by 'interesting form or light effects in nature', by capturing them in his work.[37] Both examples indicate that what he called *shumi*, or content, was not simply the visible subject matter; instead, it encompassed the tangible and the intangible. Fukuhara thus still harkened back to the concept of *shumi* as addressed by his predecessors.

That said, Fukuhara went one step further than his predecessors in de-emphasising technique while stressing the significance of intuition for the photographer. He wrote: 'Because the camera does the drawing for [the photographer] so to speak, [his] technique has little to do with the expressive quality of the finished photograph.'[38] He then insisted that it

was the photographers' intuitive apprehension (*chokkan*) of the subject, not their technique, that enabled them to express their 'spiritual life,' which he believed was the very basis of photographic art.[39] A photograph thus created had to reflect the authentic image of nature and reveal something about the spiritual life of the photographer himself at the same time:

When a photographer perceives aesthetically appealing light and tonal effects, he melts into that light, and his heart beats together with the tones. The resulting image will represent his pure soul. No matter how banal it may look, it certainly shows nature as well as the photographer himself at their purest.[40]

Fukuhara maintained that which he called 'refinement of artistic character' (*geijutsuteki jinkaku no tōya*) was crucial to the intuitive apprehension of nature and expression of spiritual life.[41] Unlike the idea of *shūyō*, this concept did not quite involve academic studies or acquisition of high morals and therefore marked an important departure from the ideas of Akiyama and Katō. The clue is in his statement from 'Light and Its Harmony', in which he said: 'Photography is a matter of 'culture' from top to bottom'.[42]

Fukuhara's choice of the English word 'culture' here is key to deciphering what he meant by 'the refinement of artistic character', and thus needs to be seen in a broader context. He explained that what he meant by the term culture was synonymous to *soyō*, which means 'explorations of the arts for strictly private enjoyment'.[43] More importantly, this word reveals his indebtedness to an intellectual current known as culturalism (*kyōyōshugi*), which arose during the 1910s and continued to exert an enormous influence on young, western minded intellectuals throughout the pre-war years.[44] Culturalism stressed individualism and the pursuit of knowledge for spiritual benefit in contrast to *shūyō*, which was centred on public

104

welfare or social advancement. Some of the leading intellectuals of the day, such as the philosopher Watsuji Tetsurō (1889–1960), encouraged their readers to explore various masterpieces of European art and literature, and re-experience themselves through them so as to gain better understanding of their inner psyche.[45]

Fukuhara's interest in culturalism is evident in the comment he made in his radio lecture. He announced his conviction that the production and appreciation of photography was 'an excellent means of cultivating good taste', which 'could help children grow intellectually' and 'enrich [our] spiritual life immensely.'[46] It is evident from this statement that he believed photography to be a significant part of culturism, one that could play the same role as the other fine arts in providing spiritual fulfilment. Indirect as it is, this reference to culturalism leads us to conclude that what he called 'the refinement of artistic character' was more personal, introspective, and non-utilitarian than the idea of *shūyō*.

Thus Fukuhara essentially shared the same goal as earlier photographers, though he envisioned a somewhat different route for getting there. This route, plotted by his advocacy of intuition and culture, reveals a greater sympathy with modernist art than had been felt by any of the earlier photographers. In fact, it even appears that he recognised a new meaning in the term *shumi* within the context of modernist photography. For instance, his descriptions of how a photographic image could convey the maker's feeling of amusement, by representing visual sensations of light and form, seem to refer to a formalist image along the line of *shinkō shashin* (New Objectiveness).[47] The term *shumi* thus encompassed a rather wide spectrum of concepts in Fukuhara's writings.

As we have seen, the rhetoric that originated in Sino-Japanese aesthetics continued to be shared by early-twentieth century photographers who pursued various approaches to their medium. Photography in general provided the Japanese with an altogether new form of visual representation; that said, quite a few practitioners elected to invoke the Sino-Japanese aesthetic concepts in explicating their ideas. Even the proponents of art photography, which was one of the first movements in the history of Japanese

Fig. 5 Portrait photograph of Fukuhara Shinzō, date unknown.

photography to be directly inspired by contemporary artistic currents in Europe, mostly continued to adopt this tactic rather than stressing contemporaneity or similarity to their western equivalents.[48] And yet, as my paper has shown, Akiyama, Katō, and Fukuhara invested the terms *shumi* and *shūyō* with multiple layers of meanings in their writings. By stressing this multiplicity, they aimed to present their medium as a part of the continuous history of visual representation and

at the same time to institute it as a new art form. Thus, essays by art photographers and their contemporaries chronicled one of the ways in which photographic authority was constructed in early-twentieth century Japan.

Notes

This research was made possible by a grant from the Sainsbury Institute for the Studies of Japanese Arts and Cultures. I would like to thank John Carpenter, Simon Kaner, Nicole Rousmaniere, Timon Screech, and Hiromi Uchida of the Sainsbury Institute, and Sebastian Dobson, Brenda Jordan, Maki Kaneko, David and Paula Newman, Raymond Pelipetz, and Yano Akiko for their feedback, support, and encouragement.

1 I use the term 'Sino-Japanese' here to describe the ideas that originated in China and subsequently became paradigmatic in Japan.

2 This paper is a part of ongoing research into the ways in which Japanese photographers of the early twentieth century attempted to internalise the new visuality that photography represented. Visuality, or 'sight as a social fact' in Hal Foster's words, is a term that refers to broader cultural implications of the changes in the nature of human vision, especially those triggered by the rise of modern art and the invention of photography. See Hal Foster, 'Preface', in *Vision and Visuality*, ed. by Hal Foster (New York: The New Press, 1988), pp. ix–xiv. I am also indebted to the following works: Jonathan Crary, *Techniques of the Observer: On Vision and Modernity in the Nineteenth Century* (Cambridge, Mass: MIT Press, 1990); Martin Jay, *Downcast Eyes: The Denigration of Vision in Twentieth-Century French Thought* (Berkeley and Los Angeles: University of California Press, 1993); and Timon Screech, *The Western Scientific Gaze and Popular Imagery in Later Edo Japan: The Lens Within the Heart* (Cambridge University Press, 1996).

3 Douglas R. Nickel, 'History of Photography: The State of Research', *Art Bulletin*, vol. LXXXIII, no. 3 (September 2001), p. 556.

4 The first photography periodical published in Japan was entitled *Datsuei yawa* and was published by Kitaniwa Tsukuba (1841–1877), one of the pioneering Japanese photographers. Inaugurations of more sophisticated journals followed, namely

Shashin shinpō (Photography News, 1889) and *Shashin geppō* (Photography Monthly, 1894), both of which were published by manufacturers of photography equipment. For more information on Kitaniwa Tsukuba, see Matsuo Jumei, 'Asakusa no shashinshi: Kitaniwa Tsukuba zakkō', *Asahi Camera*, vol. 11, no. 2 (February 1931), pp. 219–225. For information about early photography periodicals, see Mori Ippei, 'Shashin zasshi no mikata,' *Shashin shinpō*, no. 290 (November 1, 1922), pp. 37–46 and Fukazawa Yōkitsu, 'Kōen: Shashin shinpō no kigen to sono hensen', *Shashin shinpō*, no. 50 (June 1902), pp. 1–3.

5 For further details about the concept of shūyō, see Karaki Junzō, *Gendaishi e no kokoromi*, Tokyo, Chikuma shobō, 1947, rpt. in *Karaki Junzō zenshū*, vol. 3 (Tokyo: Chikuma Shobō, 1967), pp. 3–324.

6 For more information about the ideals of literati painting, see Nakamura Shigeo, *Chūgoku garon no tenkai* (Kyoto: Nakayama Bunkadō, 1982), and Susan Bush, *The Chinese Literati on Painting: Su Shih (1037–1101) to Tung Ch'i-ch'ang (1555–1636)* (Cambridge: Harvard University Press, 1971).

7 Takahashi Yuichi, 'Takahashi Yuichi rireki', in Aoki Shigeru and Sakai Tadayasu, eds., *Nihon kindai shisō taikei*, vol. 17 (Tokyo: Iwanami Shoten, 1989), p. 170.

8 Miyake Kokki, 'Shashinka shokun ni taisuru kibō (jō)', *Shashin geppō*, vol. 1, no. 11 (November 1905), p. 5.

9 The popularity of watercolour painting peaked in Japan between the 1890s and 1910s. Journals devoted to the medium, such as *Mizue* (inaugurated in 1905), and annual exhibitions of watercolour paintings hosted by the *Nihon suisaigakai* (Japan Association of Watercolour Painting, 1906) attracted a massive following of amateur painters. Miyake was one of the leaders of the movement along with Ōshita Tōjirō (1870–1911), who was the editor-in-chief of *Mizue*. Miyake was also a prolific writer on both watercolour painting and photography. He published a total of nine books on photography during his lifetime. See Nakamura Giichi, *Nihon kindai bijutsu ronsōshi*, Tokyo, Kyūryūdō, 1981, pp. 122–147 and Tokushima kenritsu bijutsukan, ed., *Mizue no akebono: Miyake Kokki o chushin to shite* (exhibition catalogue), Tokushima-shi, Tokushima kenritsu bijutsukan, 1991.

10 Sankyakusei, 'Ikani shite Shashinjutsu no hattatsu o kisubekika', *Shashin shinpō* no. 62

(November 1903): pp. 1–8. Although the identity of Mr. Tripod remains unknown, the fact that his article appeared as an editorial indicates that he was probably one of the staff writers of *Shashin shinpō*.

11 Sankyakusei, p. 7.

12 Miyake, p. 3.

13 He even confessed that he himself used to think of the camera merely as a machine for creating absolutely ugly and plebeian pictures, and that to pick up a camera would debase one's character. Miyake, p. 4.

14 Mr. Tripod stated that photography's full potential would not be realised if it became locked into the realm of the fine arts. '[We photographers] must stop competing with painters and sculptors. We must cultivate ourselves and strive for a realm higher than the visual arts', Sankyakusei, p. 5. Miyake also insisted that photography had a different goal from that of painting. Whereas a painter was free to manipulate the image in order to convey his own thoughts through his painting, a photographer was required to present a true-to-life image of the object and 'let it express the elegance [*shumi*] of nature'. Miyake, p. 11.

15 Miyake, p. 5.

16 However, he added, one should not assume that the clumsier the better; clumsiness was valued only when it was accompanied by *shumi* and gracefulness. Miyake, p. 11.

17 '... Non-professionals are able to follow contemporary artistic trends and transform their style as they wish. Therefore, they are one step ahead of professionals in terms of their *shumi* and ability to improve themselves'. Sankyakusei, p. 7.

18 Sankyakusei, p. 7.

19 Akiyama later served as the President of the Tokyo Shashin Kenkyukai (Tokyo Association for the Study of Photography), whose group show came to be regarded as the most significant exhibition venue for Art Photographers.

20 Pictorialism arose in the late 1880s in Europe. Peter Henry Emerson (1856–1936), one of the earliest Pictorialists, advocated naturalism in photography and criticised painstakingly composed images by Henry Peach Robinson (1830–1901) and Oscar Gustav Rejlander (1813–1875) that approximated academic painting. See Peter Henry Emerson, 'Photography, A Pictorial Art', *The Amateur Photographer*, vol. 3 (1886), pp. 138–39. Twelve of Emerson's followers in Britain later broke away from the Photographic Society and formed the Linked Ring, which held its own exhibition in London in 1893. Similar movements also emerged in France, Germany, Austria, and the United States. The 1892 exhibition of the London Camera Club in Tokyo, the very first public display of contemporary Western photography in Japan, opened the eyes of Japanese photographers to Pictorialism and the quality of amateur photography in Europe. Ozawa Takeshi, 'Sōron: geijutsu shashin no keifu', *Nihon Shashin zenshū* vol. 2: *geijutsu shashin no keifu*, Tokyo, Shōgakukan, 1986, pp. 146–47.

21 Akiyama Tetsusuke's comment on the first exhibition of Tokyo Shashin Kenkyukai in 1908, quoted in Ozawa, p. 149.

22 Akiyama Tetsusuke, 'Shashinka no tenshoku', *Shashin geppō* vol. 1 no. 11 (January 1906), p. 7.

23 Akiyama, pp. 7–10.

24 Katō Seiichi, 'Eigyō shashinka no hansei o motomu', *Shashin geppō* vol. 1, no. 11 (November 1906), pp. 2–3.

25 Katō, p. 12.

26 Akiyama, p. 9.

27 Akiyama, p. 9.

28 European modernist art, known collectively as 'New Tendencies' (*shinkeikō*) in Japan, was introduced at the turn of the century, mainly by western-style painters who had studied overseas such as Umehara Ryūzaburō (1888–1986). Another significant venue was provided by art and literary periodicals, especially *Shirakaba* (White Birch, 1910–23), which fervently advocated Vincent van Gogh as the paragon of the modern artist.

29 As a student Fukuhara studied Japanese-style painting with Ishii Teiko (1848–1897) and watercolour painting with western-style painter Kobayashi Mango (1870–1947), and even aspired to become a painter at one point. For more on Fukuhara's biography and his work, see: *Hikari to sono kaichō: Fukuhara Shinzō Fukuhara Rosō shashinshū 1913–1941* (exhibition catalogue), Tokyo: Watarium, 1992. The connection between watercolour painting and photography in modern Japan, as indicated by this fact and Miyake Kokki's involvement in photography, is a subject that deserves further study.

30 Fukuhara Shinzō, 'Hikari to sono kaichō', *Shashin shinpō*, no. 291 (December 1, 1922/T11), pp. 13–19.

31 Fukuhara Shinzō, 'Shashin no shumi', *Shashin shinpō*, vol. 35, no. 9 (September 1925), pp. 1–6. It was dubbed as 'the very first radio

broadcast on photography in Japan'.

32 Fukuhara Nobukazu, Higashine Tokumatsu, Murabayashi Tadashi, and Shigemori Atsushi, 'Fukuhara Shinzō, Rosō: jinsei to shashin', appendix to *Nihon Shashin zenshū* vol. 2: *geijutsu shashin no keifu*, Tokyo, Shōgakukan, 1986, p. 3.

33 Fukuhara, 'Hikari', p. 18. This statement seems to indicate Fukuhara's interest in Cézanne.

34 In his 1925 lecture, Fukuhara used the term *shumi* in at least four different ways: 1. content or the what, which he said was the focus of his talk, as opposed to technique or the how, 2. a category of photography, which, judging from his comments, consisted of non-utilitarian photographs (*shumi no hōmen no shashin*), 3. shumi as in taste, and 4. recreational hobby.

35 Emphasis mine.

36 Fukuhara, 'Shumi', p. 2.

37 Fukuhara, 'Shumi', p. 2.

38 Fukuhara, 'Hikari', pp. 14–15.

39 Fukuhara, 'Hikari', p. 15.

40 Fukuhara, 'Shumi', pp. 3–4. Although Fukuhara did not elaborate on his advocacy of intuition, empathy, and authenticity of expression, his statement here appears to have been based on some understanding of modernist art. The following passage further corroborates this point: 'In short, photographers must not be content with merely capturing the appearance [of the subject] but strive to go deeper and capture his own psyche, or else they would lag behind the singular emphasis on subjectivity and intuition in contemporary art. We photographers do not produce images mechanically. We must have pride in ourselves as artists and strive to improve ourselves artistically'. Fukuhara, 'E to shashin', *Shashin shinpō*, vol. 35 no. 8 (August 1925), p. 7.

41 Fukuhara, 'Hikari', p. 15.

42 Fukuhara, 'Hikari', p. 14.

43 'Soyō', *Nihon kokugo daijiten* vol. 12, Nihon kokugo daijiten kankōkai, ed., Tokyo, Shōgakukan, 1974, p. 448.

44 For more detailed discussions of culturalism, see the above cited essay by Karaki Junzō and the following: Tsutsui Kiyotada, *Nihongata 'kyoyo' no unmei*, Tokyo, Iwanami Shoten, 1995 and Sakamoto Takao, *Chishikijin: Taisho, Showa seishinshi danshō*, Tokyo: Yomiuri Shinbunsha, 1996.

45 Watsuji described the concept of *kyōyō* as follows: '... To give oneself various intellectual stimulations in order to nurture the spiritual shoots in one's mind ... to educate oneself through countless spiritual treasures – the arts, philosophy, religion, history – that the humanity has producted in the last thousands of years ...' Watsuji Tetsurō, 'Subete no me o tsuchikae', *Chūōkōron* April 1917, quoted in Tsutsui, p. 89.

46 Fukuhara, 'Shumi', pp. 2 and 6. The way he recommended photography to lay people as a means of cultivating taste also reflects his indebtedness to culturalism: 'Ultimately, photography too depends on the individual practitioner's artistic and intellectual background [soyō] ... It is an ideal entertainment for children since it will enable them to develop a highbrow taste. It will also help them grow intellectually. I therefore would like to recommend photography to anyone as an excellent means of cultivating good taste'. Fukuhara, 'Shumi', p. 6 (emphasis mine).

47 *Shinkō shashin*, which was characterised by geometric composition and the use of new techniques such as photogram and photomontage, arose in the early 1930s. Its major proponents included Nojima Yasuzō (1889–1964), Nakayama Iwata (1895-1949), and Yasui Nakaji (1903–1942), who were inspired by *Neue Photographie* in Germany.

48 Lifelikeness, which would have been the obvious strength of photography to most, was not an option to them either.

Contributors

Sebastian DOBSON is Honorary Librarian of the Japan Society. He graduated in Modern History at the University of Durham in 1986, and then pursued postgraduate research into the Russo-Japanese War at Corpus Christi College, Cambridge. He first went to Japan in 1989 as a Monbusho Scholar and lived in Tokyo for seven years. In 1998, he was co-organiser of the Japan Society's photographic exhibition 'The Theme and Spirit of Anglo-Japanese Relations', which was held to mark the state visit of Their Imperial Majesties The Emperor and Empress of Japan. He has lectured and written on early Japanese photography and is a member of the *Nihon Shashin Geijutsu Gakkai* (Japan Society for Arts and History of Photography).

Luke GARTLAN completed his doctoral degree at the University of Melbourne, Australia, in the Fine Arts, Cinema Studies and Archaeology Department. His thesis is on the career of the Austro-Hungarian photographer Baron Raimund von Stillfried-Ratenicz. His research interests centre on foreign photographers and artists, particularly from Central Europe and Australasia, that were active in nineteenth century East Asia.

HIMENO Junichi is Professor of the History of Economic Thought and Environmental Economics in Nagasaki University. He mainly researches into the history of photography. He recently helped to create a 'Database of Early Japanese Images' (Nagasaki University Library), completed in 1998. In 1996 he edited a book entitled *Foreign Information and Kyushu* (Kyushu: University Press), and in 1997 he wrote 'Japanese Modernization and International Informativeness', in Yasuda (ed.), *Bakumatsu Ishin* (Akasi: 1997).

Mikiko HIRAYAMA was the Robert and Lisa Sainsbury Fellow at the Sainsbury Institute for the Study of Japanese Arts and Cultures in 2002. She is currently Assistant Professor of Japanese Art History at the University of Cincinatti, Ohio. Hirayama received her PhD from the University of Pittsburgh in 2001 having already published several articles, including 'Ishii Hakutei and the Future of Japanese Painting' in *Art Journal* (Autumn 1996), pp. 57-63. Hirayama's research focuses on the study of modern Japanese art, Japanese photography, art criticism and theory.

Allen HOCKLEY received his PhD from the University of Toronto in 1995 and is Associate Professor of Asian Art History at Dartmouth College. The recipient of research awards from the Toyota Foundation, the Matsushita Foundation, and the Getty Foundation, Hockley researches both Japanese prints and early Japanese photography. His recent articles and reviews include "Shunga: Function, Context, Methodology," *Monumenta Nipponica* 55.2 (2000), pp. 257–69 and "Cameras, Photographs and Photography in Nineteenth-Century Japanese Prints," *Impressions* 23 (2001), pp. 11–17, 43–63. The University of Washington Press has published his monograph, *The Prints of Isoda Koryūsai: The Floating World and Its Consumers in Eighteenth-century Japan*. He is currently finishing a book entitled *Expectation and Authenticity in Early Japanese Photography*.

KINOSHITA Naoyuki is Assistant Professor of the Division of Cultural Resource Studies at the University of Tokyo. Kinoshita graduated from Tokyo National University of Fine Arts and Music in 1978 and became Curator of the Hyogo Prefectural Museum of Modern Art in Kobe. During his curatorship he published *Bijutsu to iu misemono* (Heibonsha, 1993, Chikumagakugei bunko 1999), *Haribote no machi* (Asahi shinbunsha, 1996), and also *Shashingaron* (Iwanami shoten, 1996). Kinoshita is also Assistant Professor at the Tokyo University Museum, University of Tokyo. His most recent publication is entitled *Yono tochukara kakusareteiru koto* (Shobunsha, 2002).

Index

Page numbers in *italic* refer to illustrations and captions.

Akiyama Tetsusuke, *101*–105
Alcock, Rutherford, 22, 70, 80
Art Photography (*geijutsu shashin*), 98, 103, 105
Asaksa (Asakusa), *56*–57, *58*–59
Atango-Yama (Atago-yama), 54–55
Beato, Felice, *23*–24, 30–38, 51, 58, 67–69, 71–75, 77–78, 80–81, 83
Bibliothèque Nationale, 44, 55
Black, John Reddie, 46, 48
Brown, Samuel Robbins, 43, 52, *53*
Brown album, 44–45, 48, 52, 55
Bunseki kyūrisho (Chemical Analysis Laboratory), 24
Burger, Wilhelm, 24–*25*, 49–51
camera obscura (*donkuru kaamuru*), 18
cartes de visite, 49, 68, 71
Choin (Chōin), 41, *42*, 46, 54–55
Club Hotel Guide to Tokyo and Yokohama, 70, 71–73
collodion (*shippan-shashin*), 18–19, 21, 24, 31, 68
Corfu, 30–31
daguerreotype (*ginban-shashin*), 18–21
Date Muneshiro, 21
Deshima, 18–21, 24–26, 49
discipline (*shūyō*), 98–99, 101–105
Donker Curtius, Jan Hendrik, 19
elegance (*shumi*), 98–105
Ensei-kikijutsu (Concerning Strange Devices from the Distant West), 20
Farsari, 71–72
Fukuda Naonoshin, 19
Fukuoka, 20–22, 27–28
Fukuhara Shinzō, *98*, 103–105

Furukawa Shumpei, 20–21
genbaku shibotsusha (victims of the atomic bomb), 87–88
globetrotter, 53, 55–58, 60, 71, 74
Gower, Abel A.J., *18*, 22
Gratama, Koenrad Walter, 24
Griffis, William, 70, 78, 82
Hakone, 44–46, 53, 61, 69, 71, 77–78
Hibakusha Aid Law (*Hibakusha engohō*), 88
Hiroshima, 86–89,
Hiroshima National Peace Memorial Hall, 86–89
HMS Phaeton, 19
Hokkaidō, 46, 49, 55, 70
Horie Kuwajirō, 21–25
Humbert, Aime, 77, *79*
ihai (mortuary tablet), 90
Illustrated London News, The, 32, 77–78
Imoto, 44–45, 48, 59
Japan and the Japanese Illustrated, 70, 77, 79–80
Japan Herald, 68
Japan Punch, 31, 68
Japan Weekly, 68
jinrikisha (rickshaw), 56, 70, 76–77
Kaempfer, Engelbert, 70, 75, 80
kago (palanquin), 77, *77*, *79*–81
Kaigun Denshūsho (Shogunal Naval College), 21
Kamakura, *35*–36
kamishimo (ceremonial dress), 20
Katō Seiichi, 102–105
Kawano Teizō, 21–22
Keeling, W.E.L., 70–73
Kikizu Mataroku, 21, 26–27
Kitano, 41, *43*, 46, 54–55
Knight's Cross of the Franz Joseph Order (*das Ritterkreuz des Franz Joseph-Ordens*), 49
Kuroda Nagahiro, 20–21

Kusakabe Kimbei, *70*, 71–73, *74–75*, 83

Kyūshū, 18–19, 26–28

Matsuki Kōan, 20

Matsumoto Ryōjun, 21, 25

Miyake Kokki, 100–103

Miyanoshita, 45, 55

Mr. Tripod (*Sankyakusei*), 100–103

musha-e (pictures of warriors), 95

Nabeshima, 19, 26

Nagasaki, 18–27, 43, 46–*47*, 48–49, *50*–51,
 69–71, 77–78, 87–89

Nagasaki-kata hikae (Nagasaki Diary), 19

Nagasaki kikiyaku (The Nagasaki Listener), 19

Nakasendō, 70, 76

Nihon shashin no kigen (The Origin of
 Photography in Japan), 23

Nikkō, 70, 74, 78, 83

Odawarra (Odawara), 41, 44–45

Parker, Charles, 49, 51, 68

Peninsular and Oriental Steamship Company, 22

Pompe van Meedervoort, Julius L.C., 21, 23, 26

Prince Kung, 36–38

Rambles Through Japan Without a Guide, 76–77

rangakusha (Dutch scholar), 18

Ransetsu Benwaku (Dutch/Japanese dictionary), 18

Rossier, P., 21–24

Saga clan, 19, 21–23, 26–27

saishin (divine spirits), 90

Satow, Ernest, 33, 36, 70–71, 78

Satsueijutsu (The Technique of Photography), 22

Satsuma, 17–18, 24–25, 32–33, 35–37, 89

Saunders, William, 68

Second Opium War, 30, 33, 36

senbotsusha (the war dead), 87

senshisha (war casualties), 87

seppuku (ritual suicide), 83

Shamitsu binran (A Handbook of Chemistry), 22

shashin-kyō (photograph mirror), 18

Shiba, 45–46, 53–54

shibotsusha (the dead), 87

shumi (elegance), 98–105

Shimazu Nariakira, Lord of the Satsuma domain, 19

Shimizu Seiji, 81, 83

Shimonoseki, 32–33, 35

Shintenfu (war trophy store house), 92–94

shūyō (discipline), 98–99, 101–105

Scidmore, Eliza, 77

Sladen, Douglas, *70*, 71–73

stereographs, 23–24

Textor and Company, 49

Tōkaidō, 41, 44–45, 59, 70, 75, 77, 80–82

Tokio (Tokyo), 70–71

Tokugawa Nariaki, Lord of the Mito domain, 19

Tracy, Albert, 76–77

Uchida Kuichi, 24–26

Ueno Hikoma, 19, 21–27, 71

Ueno Shunnojō, 19, 23

Van den Broek, Jan Karel, 20–21, 25

Views and Costumes of Japan, 42–*44*, *45*, 51, *54*,
 56–59, 72

Von Siebold, Philip Franz, 22

Von Stillfried-Ratenicz, Baron Raimund, 30,
 40–53, 55–60, 72

wafuku (Japanese-style clothing), 93

Wirgman, Charles, 31, 34–35, 68–69, 73, 81–83

Yasukuni Shrine, 89–92, 97

Yokohama, 20, 24–25, 27, 30, 35–38, 40–41,
 43-44, 46-,49, 51-52, 55-56, *58*, 60, 68-71,
 72-74, 76-78, 80-81, 83

Yoshio Keisai, 20, 24

Yūshūkan, 89–90, 92–93, 97

yakunin (Shogunal officials), 22

Reflecting Truth:
Japanese Photography
in the Nineteenth Century